PROJECT FLASH™ MX

NAT GERTLER

DEDICATION

To the animators of yesterday, today, and tomorrow.

—Nat

PROJECT
FLASH™ MX

..

NAT GERTLER

THOMSON
——————————————————————— ™ ———
DELMAR LEARNING Australia Canada Mexico Singapore Spain United Kingdom United States

Project Flash™ MX

by Nat Gertler

Business Unit Executive:
Alar Elken

Executive Editor:
Sandy Clark

Acquisitions Editor:
James Gish

Editorial Assistant:
Marissa Maiella

Developmental Editor:
Jaimie Wetzel

Executive Marketing Manager:
Maura Theriault

Marketing Coordinator:
Sarena Douglass

Channel Manager:
Fair Huntoon

Executive Production Manager:
Mary Ellen Black

Production Manager:
Larry Main

Production Editor:
Tom Stover

Cover Design:
May Mantell, Leverage Design

Library of Congress Cataloging-in-Publication
Data:

Gertler, Nat.
 Project Flash MX / Nat Gertler.
 p. cm.
 ISBN 1-4018-2601-6
 1. Computer animation. 2. Flash (Computer
file) 3. Web sites—Design I. Title

TR897.7 .G473 2003
006.6'96—dc21
 2002015544

CONTENTS

PROJECT 4 THUNDERSTORM! .31

Copying symbols • Looping controls • Copying groups of frames
• Pencil • Brush • Paint bucket • Orchestrating timing

PROJECT 5 THUNDERSTORM ON THE WEB41

Adding scenes • Dropper Tool • Publishing • Linking scenes •
Library folders

PROJECT 6 MAKE YOURSELF A PUZZLEMENT51

Importing raster images • Tracing images • Movie clips •
Mouse events • Movable symbols • Grouping • Lasso tool

PROJECT 13 ULTIMATE BALLOON BA-BOOM! GAME ..119

Multiple layers on a guide • Invisible buttons • Expanding fills

PROJECT 14 LICENSE PLATE MAKER129

Inputting text • Embedding fonts • Rounded rectangles •
Turning lines into fills • The info panel • Moving with cursor keys

PROJECT 15 CUSTOM ALARM CLOCK139

Recording sounds • Importing sounds • Panning sounds •
Editing sounds • Time objects • Conditional statements

PROJECT 19 AN ANIMATED BUSINESS CARD181

Sleek styling • Dividing one layer into several • Stopping a sound

PROJECT 20 CLOSING CREDITS191

Character animation • Translucent gradients •
Exporting a QuickTime movie

PREFACE

Welcome to *Project Flash MX*. This book will take you step by step through various interesting and fun projects you can do with Macromedia's Flash. By the time you have completed these projects, you will know from experience how to use the program. This book can be used as a stand-alone tutorial, or it can be used as part of a classroom experience.

Flash is a complex animation and programming tool, with many features and options. This book doesn't explain every single detail of every possible feature. There are books that try to do that—they are usually the size of a city phonebook (and almost as exciting). Instead, *Project Flash MX* shows you the animation and interactivity features you'll probably need, gives you tips about useful and interesting options, and builds in you a larger understanding of how Flash works. With that understanding, you will be well-equipped to grasp Flash's on-line manual's explanation of any additional features you need. This book does not go very deeply into the advance programming aspects of Flash, but it does show some simple but powerful example programs and shows you how to use the program editor.

You don't need a lot of computer experience to use this book. If you know how to use a mouse, and you have used a word processor, a spreadsheet program, or even a music program to create, save, and reopen files, you should be able to follow everything in this book without a problem.

You also don't need to be a great artist to use this book. There are some great artists using Flash, but you can do really impressive work even if you can't draw anything more complex than a stick figure. In fact, a stick figure is almost the most complex thing you'll be asked to draw in this book, and you won't get to that until the last project.

HOW THIS BOOK IS ORGANIZED

There are 20 Flash projects in this book. Each project is broken down into one-page procedures that advance the project in some visible way toward completion. If this book were *Project Lunch*, for example, the first project might be "Making a Peanut Butter and Jelly Sandwich." "Spreading the peanut butter" would be one of the procedures in that project, and that procedure would be broken down into steps ("Open peanut butter jar," "Scoop some peanut butter out of the jar with a knife," "Drag knife across the bread," and so on).

I designed the projects to be performed in order, with earlier projects showing you the most basic features of the program, and later projects demonstrating more complex and subtle uses. Sometimes one project builds on the previous project. The second project in *Project: Lunch* might be "Packing Your Lunchbox," and one of the steps might be "Take the sandwich you made in Project 1 and stick it in the lunchbox."

Later projects also presume that you have learned from the earlier ones. If the fourth project is "Make a Peanut Butter, Tuna, and Mustard Hoagie," I'm not going to spend an entire procedure telling you how to spread peanut butter again. Instead, it will just be a single step: "Spread peanut butter on the roll, as shown in Project 1, Procedure 3."

THE PROJECTS

Each project begins with a page listing the things you'll need for that project (bread, peanut butter, jelly, knife, plate) and a list of concepts that are taught in that project (spreading, slicing, and so on). In the color section of the book, you'll see pictures from the completed animations in full, glorious color.

THE PROCEDURES

Each procedure has a series of steps. Some of those steps have pictures right in the text. If I tell you to get the **Eraser** tool , that picture you see is of the button you should click on. Some steps are illustrated with pictures of parts of the program's interface. If you are asked to select some options on a dialog box, I'll show you a picture of that dialog box (and if it is a complex one, I'll circle the options you need to pay attention to). If a step requires some special mouse movement, you'll see a picture with a highlighted arrow showing you the path for the mouse.

Many of the steps have additional notes.

 Read the *Tip* notes that look like this! They show you faster and better ways of doing things.

 Why are there *Why* notes such as this one? To explain why a step is needed, and why it works as it does.

A DEEPER UNDERSTANDING: THESE SECTIONS

When you encounter an *A Deeper Understanding* section, you will find a more in-depth explanation of some Photoshop concept. You don't have to read these notes to complete the project at hand, but you probably should read them for educational value.

At the bottom of each page of each procedure is a picture. That picture is a single moment from what your animation would look like if you played it after doing that procedure. This visual cue shows you how you are building toward your intended end result. Please realize that what you see at the bottom of the page may not match what you see in your image window. For example, if the procedure is about how to zoom in on a portion of your animation so you can work on small details, the picture at the bottom will still have the entire animation rather than the enlarged portion. If you are working on a drawing that you will paste into your animation, the picture will still show the animation without the drawing in it because you haven't pasted it in yet.

The color section of this book has a series of pictures taken from each of the finished projects. Take a look through it and see what you'll soon be making!

ABOUT THE AUTHOR

Astronaut, juggler, troubadour, designer of the Mars lander—none of these descriptions truly captures the real Nat Gertler. In fact, all are laughably inaccurate, having absolutely nothing to do with Nat.

No, Nat is a writer. He has credits on over a dozen computer books, including *Easy PCs, Multimedia Illustrated,* and *Complete Idiot's Guides* on such topics as MP3s, PowerPoint, and Paint Shop Pro. His non-computer writing credits encompass a wide range of media, everything from slogan buttons to animated TV. He is most at home working in comics, where he has written everything from serious drama to adventures of the Flintstones. His self-published miniseries "The Factor" brought him a nomination for comicdom's coveted Eisner award.

Nat's efforts this year include not only *Project* books on Illustrator 10, QuarkXPress 5, Photoshop 7, and Dreamweaver MX, but also writing comic books, editing and publishing books on comics writing, writing columns and crossword puzzles for *Hogan's Alley* magazine, programming for the e-Badge.com Web site, running AAUGH.com (a site for fans of books of the Peanuts comic strip), speaking at the Charles M. Schulz Museum, performing as a motion picture "extra," and occasionally sleeping.

For more about Nat, check out www.Gertler.com.

THANKS

Thanks to the Delmar supergroup who helped turn my writings into a full-fledged instructional rock jam: front man Jim Gish, lead guitarist Jaimie Wetzel, Juanita Brown on the synthesizer, Melissa Cogswell on percussion, and Tom Stover singing "ooh, baby ooh" in the background.

Thanks also to the friends and family who contributed in various ways: Faruk Ulay, and the Gertlers Sarah, Lara, and Susan.

SCREEN GUIDE

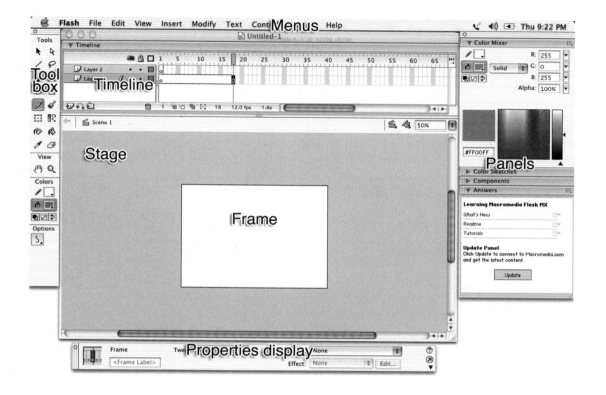

PROJECT 1

A SPOTLIGHT ON YOU

CONCEPTS COVERED

- ❏ Starting a movie
- ❏ Making a symbol
- ❏ Keyframes
- ❏ Motion
- ❏ Tweening
- ❏ Saving a movie

REQUIREMENTS

- ❏ None

RESULT

- ❏ Your name showing up in a moving spotlight

PROCEDURES

1. Open a new movie
2. Make some text
3. Create a new layer
4. Draw a spotlight
5. Make a symbol
6. Make a new keyframe
7. Animate
8. Change the background
9. Save the movie

PROCEDURE 1: OPEN A NEW MOVIE

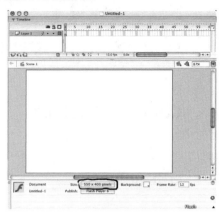

1. Start the Flash program. The program opens a new editing window.

 If the program doesn't open a new editing window, or if you need to start a new movie while you're already in the program, open the **File** menu and choose **New.**

2. Click the **Window** menu. If there's no check mark next to the **Properties** command, select that command. A properties display appears below the editing window.

3. On the properties display, click the **Size** button. A dialog box appears.

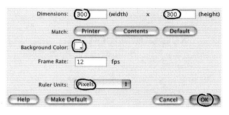

4. Click the right end of the **Ruler Units** field and select **Pixels** from the list that drops down (a type of list I refer to as a *droplist*).

 Computer screen images are made up of dots called *pixels.* Flash is generally used for creating on-screen animation; it is best to measure the size of your movies in pixels.

5. Set the **(width)** field to **300** and the **(height)** field to **300** by typing in those fields.

 By setting the size of your movie to 300 pixels × 300 pixels, you'll be able to edit the entire movie within the window space provided, and you know that it won't be too big to appear on anyone's screen.

6. Click the **Background Color** button and a *color palette* appears. Click the white square that is about halfway down the left column.

7. Click **OK.** Your movie window has a white square that is 300 pixels wide and 300 pixels high.

 If the white square is in a corner of the stage, use the scroll bars on the left and bottom edges of the window to move it to the center.

RESULT

PROCEDURE 2: MAKE SOME TEXT

1. In the toolbox, click the **Text** tool button (or just press **t,** which is the keyboard shortcut for this tool).

 If you do not see the toolbox, go to the **Window** menu and choose **Tools.**

2. The properties display now shows the settings for the text tool. Set the **Font height** field to **40.**

 The *properties display*, also called the *information area* or *property inspector*, always shows settings for the most recently selected tool or on-screen item.

3. Click the **Text (fill) color** button. A color palette appears. Click the black square that is on top of the left edge.

4. Click the **Center justify** button.

 With this option, what you type spreads outward to both sides equally.

5. Click the center of the stage.

6. Type your first name, press **Enter** or **Return,** then type your last name.

NAT
GERTLER

RESULT

PROCEDURE 3: CREATE A NEW LAYER

1. On the upper left of the editing window is the word *Timeline* with an arrowhead next to it. If the arrowhead is pointing to the right, click it. The timeline is displayed.

2. On the layer list area in the left end of the timeline, click the **Insert Layer** button. A new layer appears on the list named Layer 2.

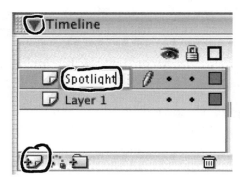

 Think of a layer as a piece of glass that you paint images on. If you paint a rose on a piece of glass and then paint a watermelon right over it, the rose is gone and you'll never see it again. But if you painted the rose then put a second piece of glass over the first then painted the watermelon on the second piece, it does hide the rose but you can see the rose again just by moving the top piece of glass.

3. Double-click the name **Layer 2.** The name becomes highlighted, letting you know that you can type a new name.

4. Type **Spotlight** then hit **Enter** or **Return.**

 Naming your layers isn't very important when you have just one or two of them. However, when you start making complex animations with dozens of layers, name each of them after what you put on them so you can find the layer you need.

NAT
GERTLER

PROCEDURE 4: DRAW A SPOTLIGHT

1. In the toolbox, click **Stroke Color** and a color palette appears. Click one of the gray squares about one-third of the way down the left edge.

This is the color of the outline of the spotlight.

2. Click **Fill Color** and choose the white square that is halfway down the left edge of the color palette.

This is the color of the spotlight itself.

3. Select the **Oval** tool from the toolbox.

4. Point to a spot about one-half inch above and one-half inch to the left of your name. *Drag* your pointer (move your pointer while holding down the mouse button) to a point one-half inch below and to the right of your name. When you release the mouse button, an oval should appear covering up your name.

If you don't manage to cover up your entire name, go to the **Edit** menu, choose **Undo,** and try again!

A DEEPER UNDERSTANDING: UNDO

Undo is your best friend. Almost any mistake you can make with your movie can be fixed with the undo command. Just go to the **Edit** menu, choose **Undo,** and the movie is restored to the way it was before you did whatever you just did. Repeat the command, and you take back what you did before that. Feel free to experiment with your movie, knowing that you have this command.

But what if your mistake is that you undid something you didn't mean to undo? Just go to the **Edit** menu and pick **Redo,** then go back to doing that voodoo that you do so well!

RESULT

PROCEDURE 5: MAKE A SYMBOL

1. Click the **Arrow** tool (keyboard shortcut: **v**) in the toolbox.
2. Click on the center of the spotlight. A dot pattern appears over the spotlight.

This dot pattern indicates that the spotlight is *selected*. Selecting something is your way of letting Flash know that you want your next command to work on this item.

3. Flash considers the outline of the spotlight (called the *stroke*) to be a separate item from the inside (the *fill*). Hold down the **shift** key then click the outline so it too is selected.

If you clicked on the stroke without holding down the shift key, Flash would have selected the outline *instead* of what was previously selected. By holding down the shift key, you let Flash know that you want to select what you click on *in addition to* what was already selected.

4. From the **Insert** menu, choose **Convert to Symbol.** A dialog box appears.

 Do you see where it says *F8* next to *Convert to Symbol* on the menu? That indicates a keyboard shortcut for that command, meaning that you can press the **F8** key instead of making that menu selection. Many commands have these shortcuts.

5. Type **The light** into the **Name** field, click the **Graphic** option, then click **OK.**

A DEEPER UNDERSTANDING: SYMBOLS

Where is this *symbol* you have created? It exists in the internal memory structure of Flash. Now you may see your oval spotlight as a bunch of pixels, but Flash thinks of it as *The light*. Flash needs to think of it like that before you can animate the spotlight. Instead of having to remember all of the thousands of pixels that make up each moment of your animation, Flash just keeps track of where *The light* is.

PROCEDURE 6: MAKE A NEW KEYFRAME

1. To the right of the layer list is the *timeline*, a grid for controlling when things happen in your animation. The timeline has a row for each layer

and across the top is a row of numbers. Click the square number **25** on the **Spotlight** layer's row.

 Animation is created showing a series of slightly different still images in rapid sequence. Each still image is a *frame*. The marking of the timeline is the *frame numbers*, so you've just selected the twenty-fifth frame.

2. From the **Insert** menu, choose **Keyframe.** Flash puts a solid dot on the timeline to note that the position of items on this layer in this frame is important. Flash also now knows that you want this layer to be visible from frame 1 to frame 25.

3. Using the **Arrow** tool ⬚, drag the spotlight off the upper-right corner of the image. That is where we want the spotlight in the twenty-fifth frame, off the image.

4. On the timeline, click square number **25** on **Layer 1** layer's row. (That is the layer with the text.)

5. From the **Insert** menu, choose **Frame** to add a frame for this layer so that Flash knows to keep the text there throughout all 25 frames of the animation.

. .

A DEEPER UNDERSTANDING: KEYFRAMES AND TWEENING

When you see a Batman cartoon on TV, a lead animator has drawn the most extreme ends of each action. He draws a frame with the hand cocked back for the punch, and then he draws another frame with the hand hitting the bad guy's chin. These are the *keyframes*.

Another animator looks at the keyframes, and draws the frames in-between, with the fist flying toward the chin. These frames are *tweens*, and the animator is a *tweener*. When setting up computer animation, you make the keyframes, and Flash tweens.

NAT
GERTLER

R
E
S
U
L
T

Procedure 7: Animate

1. On the timeline, click frame **1** of the **Spotlight** layer. The image on the editing area returns to the state you originally set up, with the oval over the text. This is your first keyframe (it is always a keyframe when you initially draw your image).

2. Drag the oval down off the lower-left corner of the movie area.

 You may need to use the scroll bars on the movie-editing window to make the lower-left area visible.

3. On the timeline, click frame **15** of the **Spotlight** layer.

 You really just need to view a frame between your two keyframes, 1 and 25.

4. From the **Insert** menu, choose **Create Motion Tween.** The spotlight now appears on your image area, a bit up and to the right of center.

 Flash just turned frames 2 through 24 into tween frames, showing the spotlight moving from the lower left to the upper right. By frame 15, the spotlight is most of the way across.

5. On the layer list, drag the **Spotlight** layer entry below the **Layer 1** entry.

Do you remember how I said that layers were like sheets of glass with images on them? You want the spotlight to be behind the text, so you're putting the piece of glass with the spotlight below the piece of glass with the text.

6. On the **Control** menu, make sure there is no check next to **Loop Playback.** If there is, select **Loop Playback** to clear the check mark.

7. On the **Control** menu, choose **Rewind** to return to frame 1.

8. On the **Control** menu, choose **Play** and watch your animation happen!

PROCEDURE 8: CHANGE THE BACKGROUND

1. Select the **Arrow** tool . The document properties are displayed in the properties display.

2. Click the **Background color** button and choose black from the color palette.

3. Click **OK.** The background area of your animation is now black, and your text isn't seen because it is black on black.

4. From the **Control** menu, choose **Test Movie.**

 This opens up your Flash Player program to show the image more as your audience will see it because they won't see all the extra stuff around the editing area.

5. The animation plays repeatedly, with your name visible only when the spotlight passes behind it. Click the window's **Close** button to stop playing the animation.

 The Close button is on the title bar at the top of the window. On a Macintosh, it is a button on the left edge of the title bar. On a Windows machine, it is the X button on the right edge of the title bar. Make sure you're clicking the Close button on the animation display window. If you click a similar button on the menu bar, you'll be closing the entire Flash program, which you don't want to do yet!

PROCEDURE 9: SAVE THE MOVIE

1. From the **File** menu, choose **Save.** A standard file browser appears. You may need to click the down arrow button to the right of the **Where** field to see the full file browser.

2. In the **Save As** or **File name** field, type **Light me up** as the name of your file.
3. From the **Format** or **Save as Type** drop list, choose **Flash MX Document.**
4. Use the **Where** or **Save In** drop list to select a folder, or double-click a folder to maneuver down into it. Get to the folder you want to store your files in.
5. Click **Save.**
6. From the **File** menu, choose **Quit** or **Exit** to leave Flash.

RESULT

PROJECT 2
A VIRTUAL DRUM SET

CONCEPTS COVERED

- ❏ Interactivity
- ❏ Buttons
- ❏ Sounds
- ❏ Squares
- ❏ Shape editing

REQUIREMENTS

- ❏ Speakers on your computer

RESULT

- ❏ A drum set you can play with your mouse

PROCEDURES

1. Create a drum symbol
2. Edit your drum
3. Give the drum a sound
4. Create a cymbal symbol
5. Make the cymbal symbol shimmy
6. Create another cymbal symbol
7. Another drum!
8. Add a cowbell
9. Add supports

PROCEDURE 1: CREATE A DRUM SYMBOL

1. Create a new movie as you did in Project 1, Procedure 1.

2. Using the technique from Project 1, Procedure 8, set the background color to dark red.

3. Set the **Stroke Color** to black and the **Fill Color** to white.

4. Get the **Oval** tool ⊙ (shortcut: **o**). On the properties display, set the **Stroke height** to 4 and the **Stroke style** to **Solid.**

> **TIP** You can set the stroke height by typing a value in the stroke height field, or by clicking the drop arrow next to it and dragging the slider that appears.

5. Hold down the **shift** key and drag to make a circle about half the height of the movie window in the lower center of the window.

> **WHY** Holding down shift tells Flash that you want an oval where the width matches the height—in other words, a circle.

6. Get the **Arrow** tool ▶ (keyboard shortcut: **v**) and click on the interior of the drum you just drew.

7. From the **Insert** menu, choose **Convert to Symbol.** A dialog box appears.

8. Type **Big drum** into the name field, set **Behavior** to **Button,** then click **OK.**

> **WHY** You might not think of a drum as a type of button, but when you hit a drum, it reacts by making a noise. For these virtual drums, you'll be clicking them instead of hitting them. To the computer, anything you click to interact with is a button.

RESULT

PROCEDURE 2: EDIT YOUR DRUM

1. Double-click the big drum. The editing window now changes so that you can use this window to edit the symbol.

2. On the timeline, click the **Down** state for **Layer 1.**

 You can tell this is a *button* you are editing by the four frames (*up, over, down,* and *hit*) listed instead of the usual timeline. Three of these are possible states of interacting with the symbol. *Up* means the pointer is away from the symbol. *Over* means it is over the symbol. *Down* means it is over the symbol and the mouse button is down. Because you want the drum to sound whenever you click it, you are setting the Down state. (The *Hit* frame defines what area of the symbol the pointer has to be on to be detected. By default, the whole symbol is selected.)

3. From the **Insert** menu, choose **Keyframe.**

 This tells Flash that you want the drum to do something different in the down state, even though you haven't yet said what you want it to do.

A DEEPER UNDERSTANDING: EDITING SYMBOLS

You can use the same symbol repeatedly in your movie, but Flash only stores it once. This helps keep movie files small and quick to download. When you edit a symbol, you change the way it appears or interacts every time it appears in the movie.

PROCEDURE 3: GIVE THE DRUM A SOUND

1. From the **Window** menu, choose **Common Libraries, Sounds.fla**. A library of sounds opens.

 Common libraries are collections of sounds and symbols that are separate from any movie. You can "check out" items from the common libraries into your movie, putting them into your movie's library.

2. Click the name of a sound, and a picture of the sound wave appears in the top of the library window. It just looks like a blue squiggle.

 Do you see *two* blue squiggles in the top area? That means the sound you selected is in stereo!

3. Click the **Play** (arrow) button in the upper right of the library to hear the sound.

4. Repeat steps 2 and 3, trying various sounds, until you find one you like.

 You won't find a sound that really sounds like a drum. Sorry! In a later project, I'll show you how to make original sounds for your movie.

5. Once you find a sound you like, drag the image of the sound wave onto the stage. When you drag it, the wave shape doesn't move but you'll end up dragging a square that represents the sound. You have now placed this sound in the Down frame of the symbol.

6. Click the words **Scene 1** above the left of the stage. The window displays your movie again, ready for editing.

7. You can test the movie as seen in Project 1, Procedure 8. When you click on the drum, the sound plays. Close the test window when you're done.

 To test the movie more easily, go to the **Control** menu and choose the **Enable Simple Buttons** option. Now you can test your buttons by clicking them in the editing window.

RESULT

PROCEDURE 4: CREATE A CYMBAL SYMBOL

1. Select the **Oval** tool (shortcut: **o**) from the toolbox.

2. Click the left part of **Stroke Color** ✏️■ then click the **No Color** button ⊠ below it.

 This lets you make a shape without an outline.

3. Click the color square part of **Fill Color** 🖌️■ . On the color picker that appears, click the blue glowing ball shape at the bottom.

 Those little balls actually indicate *gradients*, patterns that fade from one color to the next. Using one of these as your fill gives the object a shiny look.

4. Drag a shallow oval in the upper left of your image, about two-thirds as wide as your big drum but much shorter.

5. Using the technique you used in Procedure 1, make this oval a button symbol with the name **Cymbal.**

6. Using the techniques from Procedure 2 and Procedure 3, give the cymbal symbol a keyframe for the down state, and give that state a sound (pick a different sound than what you used for the drum). *Don't* click **Scene 1** to return to movie-editing mode because you are going to edit this symbol further in the next procedure.

 If you turned on the *enable simple buttons* feature, you won't be able to double-click the symbol to edit it. Instead, go to the **Edit** menu and choose **Edit in Place.**

. .

A DEEPER UNDERSTANDING: EDITING IN PLACE

When you double-click a symbol to edit it, you end up editing it *in place,* which means that you still see the entire scene and can work on the symbol in that context.

The other ways you can start editing the symbol (such as the **Edit** menu's **Edit Selected** command) isolate and center the symbol, giving you plenty of uninterrupted room to work on the symbol.

RESULT

PROCEDURE 5: MAKE THE CYMBAL SYMBOL SHIMMY

1. While still editing the down state, get the **Free Transform** tool 🔳 (shortcut: **q**) from the toolbox.
2. Click the oval to select it.
3. In the Options portion of the toolbox, click **Rotate** 🔄 . A series of squares appears around the oval. These are *rotation handles*, which you can drag to rotate the object.
4. Drag the upper-right rotation handle up and to the left. An outline of the oval rotates as you do. You don't want to rotate it very much—15 degrees should be fine.

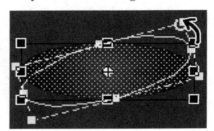

 You can rotate objects in movie-editing mode in exactly the same way!

5. Click **Scene 1** in the upper-left corner to return to movie-editing mode.
6. Test the movie again. Now when you click on the cymbal, it makes a noise and tilts. When you release the mouse button, it tilts back into its normal orientation.

RESULT

PROCEDURE 6: CREATE ANOTHER
CYMBAL SYMBOL

1. Go to the **Window** menu and choose **Library**. A window opens up, displaying a list of all the sounds and symbols in your movie.
2. Click on **Cymbal.**
3. Click the button to the right of the library window title and choose **Duplicate** from the menu that appears.
4. The symbol properties dialog box opens. Give this a **Name** of **Cymbal 2** then click **OK.**
5. Double-click the icon next to **Cymbal 2** to open the symbol for editing.
6. Click the **Down** frame for **Layer 1** on the timeline.
7. Drag a sound from the common sound library onto the symbol. (Use a different sound from the sounds you have already used in this movie.)
8. Return to movie-editing mode.
9. Drag the **Cymbal 2** entry from your library window onto your stage, above and to the right of your big drum. When you release the mouse button, the cymbal appears. You now have two symbols in your movie that look the same but are actually different symbols with different sounds.

RESULT

PROCEDURE 7: ANOTHER DRUM!

1. Drag the **Big drum** entry from your library onto the stage to the left of the existing drum. (Don't worry if the drums overlap.)

 Why does the other drum have a black stroke outline but this one is just a white circle? When you selected the drum to turn it into a symbol, you only selected the inside. The stroke is a separate object.

2. Get the **Free Transform** tool ⊞ (shortcut: **q**) from the toolbox.

3. In the Options portion of the toolbox, click **Scale** 🔲. A series of squares appears around the symbol. These are *sizing handles.*

4. Drag the upper-right sizing handle down and to the left. An outline of the symbol shape appears, showing you the size you're making it. Reduce the drum to about half its previous size then release the mouse button.

 Even though it is a different size, this is still the same symbol as the big drum. You could add a lot more of these drums without significantly increasing the file size because the drum still has just one entry in the library. However, all of these drums would sound exactly the same because the sound is part of the symbol.

5. Use the **Arrow** tool ⬉ (shortcut: **v**) to drag the drum to put it just where you want it.

 If the drum makes a noise instead of letting you drag it, go to the **Control** menu and choose **Enable Simple Buttons** to turn that feature off.

PROCEDURE 8: ADD A COWBELL

1. Get the **Rectangle** tool (shortcut: **r**) from the toolbox.
2. Set the stroke to **No color** as you did in Procedure 4.
3. Open the **Fill color** color selector, then click the steely looking gradient on the bottom of the color selector.

4. Drag a small rectangle into place to the right of the drum.
5. Get the **Subselect** tool (shortcut: **a**) from the toolbox.
6. Click the upper-left corner of the rectangle you created. The rectangle becomes outlined and small squares appear at the corners.

 The shapes in your image are defined by a series of points and the shape of the lines that connect those points. A rectangle is four points (indicated by the squares) connected by straight lines.

7. Drag the upper-left point toward the right. The top edge of the rectangle shrinks, turning it into a trapezoid, the shape of a cowbell.

8. Convert the trapezoid into a button symbol and add a sound. Do it just as you did with the drums, with one exception: add the sound to the Over frame instead of the Down frame.

This way, you'll be able to play the sound just by passing the pointer over the cowbell without having to click on it.

RESULT

PROCEDURE 9: ADD SUPPORTS

1. Set the stroke color to gray.

2. Get the **Line** tool (shortcut: **n**) from the toolbox.

3. Starting from the center of one of the cymbals, hold down **Shift** and drag downward until you reach the level of the bottom of the drums. A temporary line appears as you drag, replaced by a full line when you release the mouse button.

Holding down the shift makes sure your line goes straight down rather than being off by a slight angle. With the shift down, your line will follow one of eight basic angles no matter where you drag.

4. Repeat step 3 for the other cymbal and for the cowbell.

Notice that the line doesn't pass in front of the cymbals. This is because Flash is making these lines part of that layer background. Symbols always appear in front of the background.

5. Create a new layer as you did in Project 1, Procedure 3.

6. Set the fill color to black.

7. Use the **Text** tool (shortcut: **t**) to add a name for your band in front of the big drum on the new layer. Because it is on a new layer, it won't be covered by the drum, which is on the first layer.

If you can't think of a band name, think of the name of a favorite album, take the two most important words from it, and put them in reverse order. This way you could come up with *California Hotel, Pepper's Sergeant, HellBat, Grammar Country,* or *Father Dogg,* all of which sound as pointless as real band names. (And if I find out that all of you are naming your band *Hits Greatest,* I'm just giving up on the future of album-oriented music.)

8. Save your movie as you did in Project 1, Procedure 9, naming it **Drums.**

R
E
S
U
L
T

Project 3

A Lonely Raindrop

CONCEPTS COVERED

- ❏ Deleting points
- ❏ Adjusting angles
- ❏ Shape tweening
- ❏ Copying frames
- ❏ Animation scaling

REQUIREMENTS

- ❏ None

RESULT

- ❏ An animation of a single raindrop, splashing

PROCEDURES

1. Start your symbol
2. Make the raindrop
3. Make the rain drop
4. Splash up
5. Splash down
6. Create a ripple
7. Spread the ripple
8. Add sound
9. The ripple disappears

PROCEDURE 1: START YOUR SYMBOL

1. Create a new movie as you did in Project 1, Procedure 1.

2. From the **Insert** menu, choose **New Symbol.**

 This time, instead of making something in your movie editor and then converting it into a symbol, you'll be creating a symbol that you can then bring into the scene.

3. In the dialog box that appears, set the **Name** to **Raindrop** and **Behavior** to **Graphic** then click **OK.**

4. The editing window switches to symbol-editing mode—although you would be hard-pressed to tell the difference. Other than the listing of the symbol name toward the top of the window and the small cross that appears in the middle of the editing area, it looks just like the movie-editing mode, with good reason: a symbol is just a little animated scene of its own. You build it the same way you build a movie. Using the same method you used in Project 1, Procedure 3, change the **Layer 1** name to **Drop.**

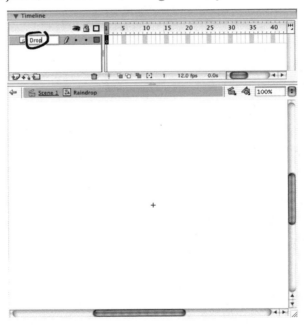

PROCEDURE 2: MAKE THE RAINDROP

1. Get the **Oval** tool ⊙ (shortcut: **o**) from your toolbox. Set the fill color to a medium blue. Click **Stroke Color** ✎■ then click the **No Color** button ☑ below it so that you're drawing objects without outlines.

2. Draw a circle about one-quarter inch across. Put it about one-half inch down from the center of the top of the window.

3. Click the **Zoom** tool ⊙ (shortcut: **z**) on the circle to get a close-up look. Click on it again to get a real close look.

4. Get the **Subselection** tool ▸ (shortcut: **a**) and drag, starting from above and to one side of the circle, heading down and to the other side. As you drag, a rectangle appears. When that rectangle encloses the entire circle, release the mouse button. A series of dots appears around your circle. These are the points that define your circle.

5. Drag a rectangle that encloses only the point at the top of the circle. That point becomes selected.

6. Point to the selected point and drag it straight up a distance about the same as the circle's height. You will find that the point you're dragging has handles on either side of it.

7. Point to one of those handles (it doesn't matter which one) and drag it so it is right above (rather than next to) the point.

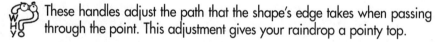 These handles adjust the path that the shape's edge takes when passing through the point. This adjustment gives your raindrop a pointy top.

8. Get the **Pen** tool ◈ (shortcut: **p**). While holding down the Windows **Ctrl** or Macintosh ⌘ key, drag a diagonal across the raindrop shape to reselect it.

9. Click twice on each point above the middle of the drop *except* the point you dragged up earlier. When you click a point, it disappears.

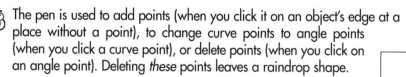 The pen is used to add points (when you click it on an object's edge at a place without a point), to change curve points to angle points (when you click a curve point), or delete points (when you click on an angle point). Deleting *these* points leaves a raindrop shape.

PROCEDURE 3: MAKE THE RAIN DROP

1. Between the timeline and the stage on the right side of the editing window is a drop list that shows the current magnification percentage. Open the drop list and choose **Show Frame**. The display demagnifies and becomes centered.

2. Click on frame **6** of the **Drop** layer on the timeline.

3. From the **Insert** menu, choose **Frame**. Flash sees that you want this layer to be active in frame 6 and makes it active for frames 2 through 5 as well.

4. From the **Insert** menu, choose **Create Motion Tween**. Flash puts a dotted line on the timeline; it knows you are going to create a motion but it hasn't seen that motion yet.

5. Using the **Arrow** tool , drag the raindrop down to about an inch from the bottom of the window. This shows Flash where you want the raindrop to be in frame 6. It now knows what motion you want to do so it puts an arrow between frames 1 and 6 on the timeline, indicating there is a motion.

6. Press your **Return** or **Enter** key. You'll see the animation of the raindrop falling.

A DEEPER UNDERSTANDING: SYMBOLIC THINKING

You may remember from Project 1 that you turned the spotlight into a symbol for tweening it. Then I said that an object needs to be a symbol to be motion tweened. But you just made the drop move without its being a symbol, right? Wrong! From the **Window** menu, choose **Library** and you'll see a new symbol in your library. When you told Flash you were going to tween, Flash automatically turned the drop into a symbol named *Tween 1*.

Here is food for thought: That Tween 1 symbol is just part of the Raindrop symbol you are building. It is a symbol within a symbol! Flash lets you use small symbols to build up bigger symbols and use those in even bigger symbols.

PROCEDURE 4: SPLASH UP

1. Using the method from Project 1, Procedure 3, create a new layer and name it **Splash.**

2. On the timeline, select frame **6** of the **Splash** layer then go to the **Insert** menu and choose **Insert Keyframe.**

3. Select the **Oval** tool (shortcut: **o**) from the toolbox. Leave the fill color at the same blue as before and return the **Stroke Color** to its **No Color** setting.

You haven't actually changed the stroke color since setting it to No Color in Procedure 2. However, since then you've used the subselect tool and the pen tool, both of which turn the stroke color back on even though you didn't use them to create a stroke on anything.

4. Create an oval about 2 inches wide and 1/2 inch high that covers up all but the very top of the raindrop.

5. On the timeline, select frame **12** of the **Splash** layer then go to the **Insert** menu and choose **Insert Keyframe.**

6. Use the **Subselection** tool (shortcut: **a**) to select the oval, just as you selected the circle in Procedure 2.

7. Select the point on the upper-left edge of the circle. Drag it up and to the left. Repeat this with the point on the upper right. Don't make it symmetrical. This is supposed to look like water splashing, and water rarely splashes precisely.

8. On the timeline, select frame **6** of the **Splash** layer.

9. The properties display now shows frame information. Set the **Tween** drop menu to **Shape.**

Instead of tweening the position of an item, this animates the oval from frame 6, morphing into the splash shape you created in frame 12. Hit **Return** or **Enter** to test it!

PROCEDURE 5: SPLASH DOWN

1. On the timeline, select frame **6** of the **Splash** layer.

2. From the **Edit** menu, choose **Copy Frames.** The contents of this frame on this layer (i.e., the blue oval) are copied into an area of your computer's memory called the *clipboard*.

3. On the timeline, point to frame **12** of the **Splash** layer then drag to frame **17.** As you drag, the whole series of frames become selected (indicated by them turning dark on the timeline).

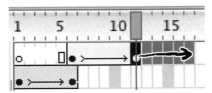

4. From the **Insert** menu, choose **Frame.** Because you selected six frames, six frames are added. This extends your active frames out to frame 18.

5. On the timeline, select frame **18** of the **Splash** layer.

6. From the **Edit** menu, choose **Paste Frames.** The frame you copied onto the clipboard is now copied into frame 18, leaving the blue oval there.

7. On the timeline, select frame **17** of the **Splash** layer.

8. On the properties display, set the **Tween** menu to **Shape.** This creates a tween from frame 12 to 18, bringing the splash back down to the oval.

RESULT

PROCEDURE 6: CREATE A RIPPLE

1. Create a new layer and name it **Ripple.**

2. On the timeline, select frame **6** of the **Ripple** layer and make it a keyframe. The keyframe dot may not appear on the timeline until the next step.

3. Get the **Oval** tool ⃞ then click the **Switch Colors** button ⃞ .

 > The switch colors button swaps that stroke and fill colors. This turns the stroke color to the blue you've been using.

4. Click the **Fill Color** button ⃞ then click the **No Color** button ⃞ .

 > You're creating just the outline of an oval, with no fill in the center.

5. On the properties display panel, set the **Stroke height** to **3.**

6. Drag an oval into place that surrounds the blue oval of the splash layer, with a few pixels margin all around.

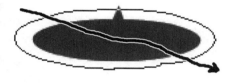

7. On the timeline, select frame **5** of the **Ripple** layer then go to the **Insert** menu and choose **Frame.**

 > You wanted to draw the ripple in frame 6 so you can use the splash oval as a guideline. However, you don't want the ripple to start until the water is actually splashing up. By inserting a blank frame here, you move the first appearance of the ripple oval up to frame 7.

8. Point to the word **Ripple** on the timeline and drag the layer down until it is in the bottom of the layer list.

 > When the splash splashes up, you want it to obscure the far side of the ripple. It may not seem to make much difference now, when the ripple and the splash are the same color, but you're going to change the color of the ripple in later frames.

RESULT

PROCEDURE 7: SPREAD THE RIPPLE

1. Select frame **7** on the **Ripple** layer. When you do this, the oval should be automatically selected, which you can see by its speckled color.
2. From the **Insert** menu, choose **Convert to Symbol.** In the symbol properties dialog box, name the symbol **Ripple** and set **Behavior** to **Graphic** then click **OK.**
3. Select frame **22** on the **Ripple** layer and make it a keyframe.
4. Get **Free Transform** tool . Sizing handles appear around the oval.

5. Drag one of the corner sizing handles away from the center of the oval. As you do, an outline shows the new size for the oval. Keep dragging until the oval is about twice as wide and twice as high as before then release. The oval changes size.
6. Select frame **7** on the **Ripple** layer then go to the **Insert** menu and choose **Create Motion Tween.** Flash creates the tween frames, showing the ripple spreading outward.
7. Select frame **22** on the **Ripple** layer.
8. Get the **Arrow** tool ⬉. The properties display shows options for the currently selected symbol. Set the **Color** drop list to **Tint.** Click the color picker button to the right and choose a light blue.

The *Color* settings allow you to create different changes in color to accompany a motion tween. Both the Alpha and Brightness settings could also be used to cause the oval to fade out, although you wouldn't have as wide an array of colors to choose from.

PROCEDURE 8: ADD SOUND

1. Create a new layer and name it **Sound.**
2. Select frame **6** of the **Sound** layer.

 You want the viewer to think the sound comes from the raindrop hitting the surface, which happens in frame 6.

3. Make this frame a keyframe. Otherwise, when you put the sound in, Flash will automatically assume you want it to start in frame 1.
4. Open the common sound library and find the most appropriate sound you can as you did in Project 2, Procedure 3.

 Of the sounds that come with Flash, my favorite splashing sound is *Book Drops* because it has two hits, as if there is a secondary sound caused by the splash bouncing (even though it doesn't properly align with the splash drop on the animation).

5. Drag the sound from the library onto the editing window. A picture of the sound wave appears on the timeline, starting in frame 6.

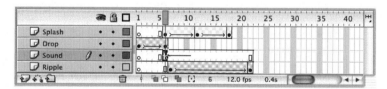

PROCEDURE 9: THE RIPPLE DISAPPEARS

1. Select frame **23** on the **Sound** layer.

2. Go to the **Insert** menu and choose **Frame**.

 By adding a frame on this layer, you're making the symbol's animation last one frame longer than the ripple does. This way, the ripple doesn't stay on screen when the animation is over.

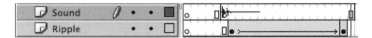

3. Test the animation by going to the **Control** menu, choosing **Rewind** (which selects frame 1), then on the same menu, choosing **Play**. After playing, you can repeat the animation by choosing **Play** again, because Flash recognizes that if you ask it to play the animation when it is at the last frame, you probably want it to start from the first frame.

 Why not use the **Test Movie** command to see your animation? Because you haven't created an animation in the movie scene itself. You've created this raindrop symbol, but you haven't put the symbol anywhere.

4. Save this file. Name it **Raindrop.**

Project 4

Thunderstorm!

CONCEPTS COVERED

- ❏ Copying symbols
- ❏ Looping controls
- ❏ Copying groups of frames
- ❏ Pencil
- ❏ Brush
- ❏ Paint bucket
- ❏ Orchestrating timing

REQUIREMENTS

- ❏ The file you created in Project 3

RESULT

- ❏ An animation of a thundershower

PROCEDURES

1. Zoom out
2. Place a layer of drops
3. Add smaller drops
4. Copy further layers of drops
5. The puddle
6. The pitter-patter on the puddle
7. Lightning strikes
8. Lightning flashes
9. Thunder

PROCEDURE I: ZOOM OUT

1. Using the techniques from Project 1, Procedure 1, open a new movie. Set the background color to black and the dimensions to **500 pixels** wide × **400 pixels** high, with a **Frame Rate** of **12** fps.

2. Click the magnification drop list button on the right edge of the editing window, between the timeline and the stage. On the menu that appears, choose **50%.** The size of your movie shrinks, so that the entire movie is visible on your stage, with lots of margin. You haven't actually changed the movie at all; you've just changed your view of it, so that you can better work on things that go beyond the edges of the movie.

3. From the **File** menu, choose **Open as Library.**

4. A file browser opens. Select the file **Raindrop** that you saved in Project 3, then click **Open.** A library window opens, displaying the symbols you created and the sounds you used in Project 3.

RESULT

PROCEDURE 2: PLACE A LAYER OF DROPS

1. Drag the **Raindrop** entry in the library onto the movie, placing it just above the top edge near the left end of the frame.
2. On the properties display select **Play Once** from the lower drop list.

Otherwise, Flash assumes that you want this symbol to *loop* (repeat), so the same raindrop splashes in the same place again and again.

3. Select frame **50** of **Layer 1** on the timeline. Go to the **Insert** menu and choose **Frame**. Flash now knows you want at least 50 frames of animation and displays the fiftieth frame to you.
4. Select frame **20** of **Layer 1** on the timeline. Use the **Arrow** tool to drag the visible part of the symbol (the ripple—by this frame, the drop and splash are gone), making sure it is in the lower half of the image. It is okay if one side of it goes off the edge.
5. From the **Edit** menu, choose **Copy.** The symbol is copied onto the clipboard.

You could keep placing the symbol by dragging it from the library, but then you have to set the play once setting every time. Copying the symbol also copies the setting, which will be in place when you paste it.

6. Select frame **3** on the timeline and make the frame a keyframe.
7. From the **Edit** menu, choose **Paste.** A new raindrop appears. Use the **Arrow** tool to place the drop near or above the top edge, anywhere you want horizontally.
8. Select the frame that is 19 frames after the current one, click a blank spot to deselect the symbols, and adjust the ripple to make sure that it is in the lower half of the frame.
9. Repeat steps 6 through 8, placing raindrops in frames 7, 8, 15, and 22.

RESULT

PROCEDURE 3: ADD SMALLER DROPS

1. Place a second raindrop in frame 22.

 You already made this frame a keyframe. You don't have to make it a keyframe again.

2. Go to frame 41.
3. Get the **Free Transform** tool and click on the image away from any of the ripples.

 When you go to a frame, Flash selects all the objects in that frame. However, you only want to select one of the items. Clicking on a blank spot deselects things so you can click one of them.

4. Click the ripple for the raindrop you just added. Sizing handles appear around the ripple.

5. Drag one of the lower corner handles toward the oval's center. An outline of the oval shrinks and moves upward. Shrink it to about two-thirds of its original size.

The oval moves upwards because it is not just the ripple you're scaling down. You are scaling down the whole symbol, including the raindrop and the splash. Everything is moving toward the center of the symbol's full height, starting from the top of the raindrop before it falls.

6. Get the **Arrow** tool and drag the ripple so that it is just below the halfway point of the frame.
7. From the **Edit** menu, choose **Copy** to copy this reduced symbol.
8. Select frame **30** and set it as a keyframe. Then go to the **Edit** menu and choose **Paste in Place.** The new raindrop shows up in the same location as the symbol you copied.

Resist the temptation to go back and add more raindrops to earlier frames. The symbol would only be added in frames up to the next keyframe, so you won't get the full animation.

PROCEDURE 4: COPY FURTHER LAYERS OF DROPS

1. On the timeline, click the layer name to select the entire layer, including all 50 frames.

2. From the **Edit** menu, choose **Copy Frames.** All the frames are copied onto the clipboard.

3. Create a new layer and select the whole layer by clicking the layer name on the timeline.

4. Clear the frames of the new layer by going to the **Insert** menu and choosing **Remove Frames.**

 When you create a new layer, Flash automatically puts blank frames ranging from the beginning of the animation to the last frame that any layer has anything on. A blank frame is not the same as having no frame there at all. Having blank frames left at the end of your movie can cause the movie to run longer than you intended.

5. Select frame **33** on the new layer on the timeline.

6. From the **Edit** menu, choose **Paste Frames.** The timeline from layer 1 is copied onto this new layer, shifted 32 frames over. What this means is that you've just doubled the number of raindrops in your animation. It is true that the raindrops *will* be hitting in exactly the same place that the raindrops hit 32 frames earlier, but the screen will be busy enough that folks won't notice!

7. Repeat steps 3 through 5, but this time paste the new frames into frame **71** of the new layer. This creates frames all the way out to frame 120. At 12 frames per second, you now have 10 seconds of animation.

RESULT

PROCEDURE 5: THE PUDDLE

1. Create a new layer and name it **Puddle.** Select the first frame of this layer.
2. Get the **Pencil** tool (shortcut: **y**) from the toolbox.
3. On the properties display set the **Stroke style** to **Solid** and the **Stroke height** to **3**. Click the color button then click on the biggest ripple on the screen. The ripple's color becomes the stroke color.
4. In the options section of the toolbox there is a single button called **Pencil Mode.** Press it down and a menu appears. Choose **Smooth** from this menu.

These options automatically smooth out any line you draw with the pencil, giving it graceful curves.

5. With the pencil, drag a slightly waving line across your frame, just over halfway up from the bottom.

Don't try to start at the very edge. Start off of one side and keep going until you run off the other side.

6. Put the pencil where your wavy line hits the side of the frame. Drag down along the edge, then across the bottom edge and up the other side so you have a rough, four-sided shape with black in the center.

7. Click **Switch colors** to move the stroke color you selected down to the fill color.
8. Get the **Paint Bucket** tool (shortcut: **k**) and click on the black interior of the shape. The shape fills with color.
9. Drag the **Puddle** layer to the bottom of your layer list so it won't cover up the splashes.

PROCEDURE 6: THE PITTER-PATTER ON THE PUDDLE

1. Test the movie by going to **Control** and choosing **Test Movie.** As the movie repeats, you'll notice there is *no sound!* Close that test window.

 Quite simply, when you place a symbol as a graphic, the sound gets lost. There is a way to use a symbol that keeps the sound, but it is more complicated.

2. Create a layer named **Sound,** and select frame **1** of that layer.
3. On the properties display pull down the **Sound** menu. You'll find the sound you added to the symbol there. Select it. The sound wave appears on your sound layer.

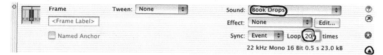

 This menu lists all the sounds in this movie's library. When you put the symbol into this movie, Flash brought over all of the components of the symbol, including the sound.

4. If the arrowhead in the lower right of the properties display points downward, click it. The display expands to show all the options.
5. Under the name of the sound is information about the sound, including its length (such as *0.5 s*—that is half a second). Divide 10 by that figure to see how many times the sound needs to repeat to last for your entire 10 second animation. Enter the result in the Loops field.

 If you can't do the math just keep increasing the loops value by 1 then check the timeline. When the wave pattern on the timeline reaches all the way out to frame 120, stop!

6. Create a **Sound 2** layer and select the first frame.
7. Open the common sound library, find a good rain sound and drag it onto your image. If the sound panel says it is the same length as the previous sound, find a different sound.

 One repeating sound is too rhythmic and unnatural. Two sounds repeating at different speeds make the rhythm harder to detect.

8. Repeat step 5.

RESULT

Procedure 7: Lightning strikes

1. Select the **Puddle** layer on the timeline by clicking its name, then click the new layer button. Name the new layer **Lightning.**

 When you click the new layer button, the new layer appears on the list immediately above the currently selected layer. Because you want the lightning to be in the distance, behind all the splashes, you need it low on the list.

2. Clear the blank frames from this layer, just as you did in Procedure 4.

3. Select frame **65** on the **Lightning** layer. Make it a keyframe.

4. Get the **Pencil** tool (shortcut: **y**), and set the **Stroke height** to **5** and the **Stroke color** to white.

 You can set the stroke color either on the stroke panel or on the toolbox. They are just two ways of adjusting the same setting.

5. Click the button in the Options area and choose **Straighten**.

 This setting can make sharp lines from most of what you draw.

6. Draw a jagged lightning line from the center of the top edge down toward the puddle (but don't reach the puddle).

7. Select frame **66** of this layer, then go to the **Insert** menu and choose **Blank Keyframe.** This command creates a new keyframe without copying the contents of the previous keyframe. That way, the lightning is only up for one frame, one-twelfth of a second.

8. Put another keyframe in frame **67** and draw another lightning line there. This line should start in the center and head down and to one side, again without reaching the puddle.

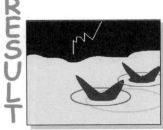

PROCEDURE 8: LIGHTNING FLASHES

1. Create a new layer and name it **Flash.** Clear the blank frames from the layer.

2. Select frame **65** of the new layer and insert a keyframe there.

3. Click the **Fill Color** button and click the blue gradient ball at the bottom. Your fill color becomes the blue gradient.

 This works even if you had the stroke color button selected in your toolbox. Flash won't let you have gradients as the stroke color, so when you click a gradient, it knows you want it as your fill color.

4. Get the **Rectangle** tool (shortcut: **r**) and drag a rectangle into place that covers the entire frame.

5. On the timeline, drag the **Flash** layer down to the very bottom of the stack, below the puddle layer.

 This is the *lightening* of the sky caused by the *lightning.* We want this glow to appear behind the lightning and not cover up the puddle or anything else. It is strictly in the background.

6. Select frame **67** of the **Flash** layer.

7. Go to the **Insert** menu and choose **Frame.** The program makes a block running from the keyframe in frame 65 to this frame. The sky will now glow the whole time the lightning is flashing, including during the one-frame gap between lightning strikes.

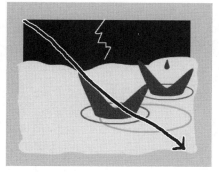
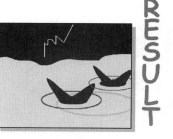

PROCEDURE 9: THUNDER

1. Create a new layer and name it **Thunder.** Clear the blank frames from the layer.

2. You now have a choice to make: Do you want the thunder to sound at the exact same time as the lightning flash, which will make sure that the viewer recognizes the thunder as thunder? Or do you want the thunder delayed a little bit, a more realistic effect? If you want a simultaneous sound, select frame **65** of the new layer and insert a keyframe there. For the realistic effect, use frame **71** instead.

 Lightning and thunder occur at almost the same time, but light travels much faster than sound. If lightning strikes a mile away, you'll see the lightning immediately, but it will take the sound about 5 seconds to reach your ears. As such, the half-second delay isn't realistic unless the lightning is only one-tenth of a mile away. I suggest using the simultaneous sound.

3. Open the common sound library, find a good sound, and drag it onto the movie.

 I like the sound **Metal Klank** for this purpose. Don't worry that the sound is much longer than the one-twelfth of the second the frame takes up. Once you start a sound playing, Flash will play it until it ends, unless you do something else to stop the playing.

4. Save the movie and name it **Thunder.**

5. Watch the thunderstorm. Go to the **Control** menu and select **Rewind,** then select **Play** from the same menu.

Don't worry if the sound keeps playing after the animation stops. Playing a movie in the editing window can cause timing problems that you'll rarely have in the test window or when your movie is viewed in a Web browser.

PROJECT 5

THUNDERSTORM ON THE WEB

CONCEPTS COVERED

- ❏ Adding scenes
- ❏ Dropper tool
- ❏ Publishing
- ❏ Linking scenes
- ❏ Library folders

REQUIREMENTS

- ❏ The file you saved in Project 4

RESULT

- ❏ A Web page presentation of your thunderstorm animation, with opening and closing screens

PROCEDURES

1. Add a scene
2. Bring back the blue
3. Add a title
4. Add a button
5. Make 'em wait!
6. Add some closing credits
7. Set your options
8. Publish and test!

Procedure 1: Add a scene

1. Open the animation you saved at the end of Project 4 by going to the **File** menu, choosing **Open,** and selecting the **Thunder** file with the file browser that appears.

 Open up the **File** menu and choose the **Open Recent** submenu. The last few files you saved will be listed there. If you see an entry that looks like **1Thunder.fla**, click it and the file opens right up!

2. Go to the **Insert** menu and choose **Scene.** Suddenly, the entire animation disappears! The screen goes blank and the timeline is empty. Is all your hard work gone? *No!* You're just creating another *scene,* a separate section of your movie. Your movie can be made up of any number of scenes in a row.

3. Go to the **Window** menu and choose **Scene.** The scene panel opens.

4. Double-click the words **Scene 2** and type **Title,** then press the **Enter** or **Return** key.

5. Point to the word **Title** and drag to above **Scene 1.** When you release, the two scenes have switched order.

 The order of the scenes on the list is the order you'll watch them in during the video. You want the title to be before the rainstorm, not after.

• •

A DEEPER UNDERSTANDING: SCENES

If you think of scenes as the scenes in a play, you have the right idea. In a straightforward movie, you'll see one scene, then another, then another, and the entire contents of each scene may be different.

Scenes don't *have* to be played in order, however. If you're doing an interactive project, you might have one button that takes the viewer to Scene 2 and another button that takes you to Scene 8.

PROCEDURE 2: BRING BACK THE BLUE

1. This animation has a very simple color scheme, and the title should match it. Let's use one of the colors from the animation. You could *try* to pick the same color again, but do this the right way and actually get the right color. First, click the **Edit Symbols** button above the upper-right corner of the editing window and choose **Raindrop** from the menu that appears. The editing window now displays the raindrop animation.

2. You want to set the fill color so click the right side of the **Fill Color** button .

3. The color palette opens up and your pointer becomes an eyedropper. Point the bottom of the eyedropper to the raindrop then click. The fill color is set to the raindrop's color.

4. Click **Title** in the upper left of the editing window. The editing window returns to displaying the still-blank scene.

A DEEPER UNDERSTANDING: EYEDROPPERS

The eyedropper pointer you used in this procedure looks a lot like the eyedropper tool in the toolbox. If you've used other graphics programs, your instinct may be to grab the eyedropper tool from the toolbox to click on the raindrop. Don't. The eyedropper tool can only select the color from certain types of objects on the stage. It can't take the color from a symbol embedded in the current scene, so it can't even get the raindrop color. The eyedropper you use in this procedure can get not only any color from the stage, but also any color from the whole screen—even from another program!

RESULT

PROCEDURE 3: ADD A TITLE

1. Get the **Text** tool Ⓐ (shortcut: **t**) and drag across the right two-thirds of the top of the frame.

2. On the properties display, set **Font** to **Arial,** the **Font height** to **96,** the **Character Spacing** (the spacing between letters) to **–20,** and click the **B** button (that's **B** for **Bold!**) and the **Right/Bottom Justify** button.

3. Type **THUNDER** in all capital letters then press **Enter** or **Return** and type **STORM.** ⊞

4. Get the **Free Transform** tool and drag the logo so the upper-right handle dot is in the upper-right corner.

5. Point to the upper edge of the box around the text (*not* on a handle dot) and drag to the left. The logo *skews,* tilting the sides without rotating the top or bottom edges.

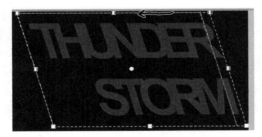

A DEEPER UNDERSTANDING: FONTS

When you add text to your movie, Flash copies the font design from your system, making it part of your movie file. The viewer doesn't have to have that font installed to see it.

Choose a font named *_sans, _serif,* or *_typewriter,* and no font design is included in your file. Instead, when someone opens that movie, the Flash player checks their system and finds an appropriate font (a plain-edged *sans serif* font, a *serif* font with little tics on the edges of the letters, or an evenly spaced font). The text on their system might not look quite the same as on your system but it should be close. These *device fonts* won't work if you change tracking or skew your text so they are no good for this project.

RESULT

PROCEDURE 4: ADD A BUTTON

1. Open the common button library by going to the **Window** menu and choosing **Common Libraries, Buttons.fla.**

2. Double-click the icon to the left of **Playback**. A list of button symbols appears below it.

 This icon indicates a *folder*, a collection of symbols organized together to make them easier to find.

3. Drag the **gel Right** symbol onto an open area of the stage. An outline or handle dots show that the button is selected. Don't mess with anything! Just go to the next step.

4. From the **Window** menu, choose **Actions.** The object actions panel opens.

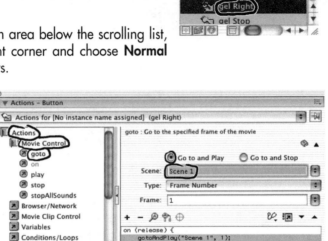

If the panel doesn't have an open area below the scrolling list, click the arrow in the upper-right corner and choose **Normal Mode** from the menu that appears.

5. Click **Actions**. On the list that appears, click **Movie Control**. Another list shows commands that can be used with the button.

6. Double-click **Go To.** Some options appear in the right part of the panel.

7. Set **Scene** to **Scene 1** and make sure that **Type** is **Frame Number** and the **Go to and Play** option is selected. Your button is now set to advance the movie to the next scene.

..

A DEEPER UNDERSTANDING: ACTIONS

Flash can help you do much more than make good animation. By assigning actions to symbols and frames, you can create simple interactivity (such as the button you made here), games, or other useful tools. You can do a lot without learning Flash's programming language, *ActionScript.* In this procedure, you clicked a few logical buttons and Flash built a program for the command you wanted. You can see the program in the lower right of the actions panel.

PROCEDURE 5: MAKE 'EM WAIT!

1. Creating a button to advance to the next panel is a fine thing to do, except for one problem: when a scene is done, the Flash player advances to the next scene automatically anyway. Because this title scene has just one frame, it would only be up there for one-twelfth of a second before moving on to the animation. You want something to make it stop and wait for the user to press the button. On the timeline, double-click on the **Layer 1** entry for frame **1.** The action panel now says *Actions-Frame* at the top to show that you are setting the action that occurs when this frame is displayed.

2. On the action panel, the Movie Control book should still be open. Double-click **Stop.** Notice that there aren't any menu selections that appear at the bottom, the way they appeared in Procedure 4. *Stop* is a very simple command and there is nothing you can vary about it.

3. Close the actions panel, either by clicking on the close button on the top of the panel or by going to the **Window** menu and choosing **Actions.**

 Take a look at the timeline. Do you see that letter *a* in frame 1? That *a* is for *action*—it means there is an action in this frame.

PROCEDURE 6: ADD SOME CLOSING CREDITS

1. In the scene panel, click the **Title** entry, then click the **Duplicate Scene** button. A new entry called *Title copy* appears.

2. Using the techniques from Procedure 1, move the **Scene 1** entry down to between the other two entries, then rename the **Title Copy** entry as **Closing credits.**

3. As you can see above the left of the stage, you are now editing the *Closing credits* scene but it looks just like the Title scene. That should come as no surprise because you duplicated that scene. It has the things you want at the end—it has the stop command to keep the film from going on, and it has a button you can push to play the animation again. All you need to add is a little text. Get the **Text** tool , pick a small font size, set the color to white, set the tracking back to **0,** and put the words **A short, wet movie by Nat Gertler** in an open area, then use the **Arrow** tool to drag it between THUNDER and STORM.

 Use your own name. Don't use Nat Gertler unless your name *is* Nat Gertler, which would be very freaky. If it is your name, drop me a line at Nat@Gertler.com—I'd love to meet me.

4. Next to the button, put the question **Rain again?** If you want to redesign the screen a bit, you can move the button first.

 If you click on the button to select it, you may find the animation suddenly playing. Why? Because you set up the simple buttons option when you were working on a previous project. That option makes the buttons in the editing window actually work. You can turn off the option by going to the **Control** menu and choosing **Enable Simple Buttons.** You can avoid the problem even with the option on—get the **Arrow** tool, drag a rectangle around the button, and release. Now the button is selected and you can move it using the cursor keys on your computer. Holding down **Shift** while using the cursor keys moves the button faster.

RESULT

PROCEDURE 7: SET YOUR OPTIONS

1. Go to the **File** menu and choose **Publish Settings.**

2. A publishing settings dialog box opens. It has three tabs. Click the **Formats** tab, and make sure that the options **Flash (.swf)**, **HTML (.html)**, and **Use default names** are the only ones selected.

 These are the only options you need to create a Web page that anyone with a Web browser that has a Flash player can view. The other options create movies and still images viewable with other types of players.

3. Click the **Flash** tab. Clear all the option boxes except **Compress Movie** and set **Version** to **Flash Player 6.**

 If you set a lower version, Flash strips out of your movie every feature that is not supported by earlier versions of Flash's player software. That won't change a simple movie like this because you're using very basic features of Flash. With advanced projects, this could cause it not to work for anyone. The easiest choice is to leave it at the current version, although some folks might have to upgrade their Flash player to view some of your movies.

4. Click the **HTML** tab and set the **Template** to **Flash Only.** Clear all of the playback options except **Display Menu**—you have already designed it to pause at the start, and because the last scene has a stop command, it couldn't loop if it wanted to. Set the **Quality** to **Auto High** then click **OK.**

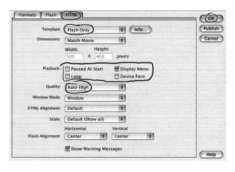

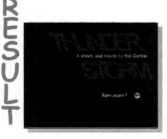

 The quality setting decides whether Flash smoothes the edges of its angles and curves. If you set it to **Low,** no smoothing takes place. If you set it to **High,** smoothing takes place, but that can slow down your animation on a slow computer. Set it to **Auto High** and the animation starts playing at high. If the computer can't keep up, it switches back to low quality.

PROCEDURE 8: PUBLISH AND TEST!

1. Save your file.
2. From the **File** menu, choose **Publish Preview, HTML.** Flash puts together your Web page and the player version of the movie file. Your Web browser opens up and displays the movie! Luxuriate in the beauty of what you have created.

 If you want to create the HTML and player without automatically viewing it, go to the **File** menu and choose **Publish.**

A DEEPER UNDERSTANDING: WEB PAGES

Your movie appears within a rectangle on a Web page, just like the still photos you might see on the Web. Flash creates a very simple Web page for showing your movie. All it has is your movie and a background with the same color as the background you set for your movie. However, you can use any standard Web editor to change the page that surrounds your image. You can add text and pictures and change the color. Those things will all change what appears around the movie, but they won't change the movie itself.

HTML, the *Hyper-Text Markup Language,* is the system used to describe the content of a standard Web page. I can't cover it in this book but learning the basics is fairly easy. HTML files consist mostly of the visible text that make up your page, plus *tags*—added commands in <brackets> that tell the Web browser how to format the page and what images to add. When you are editing the HTML file for your Flash movie, you can add anything you want. The important thing is to make sure that you do not remove the tag that starts with *<OBJECT,* the tag *</OBJECT>,* or any of the tags between those two. Those are the tags that set up the movie and its parameters.

RESULT

PROJECT **6**

MAKE YOURSELF A PUZZLEMENT

CONCEPTS COVERED

- ❏ Importing raster images
- ❏ Tracing images
- ❏ Movie clips
- ❏ Mouse events
- ❏ Movable symbols
- ❏ Grouping
- ❏ Lasso tool

REQUIREMENTS

- ❏ A digital picture of yourself (or, barring that, any digital image scanned in or downloaded from the Web)

RESULT

- ❏ A simplified version of your image as a puzzle

PROCEDURES

1. Import your picture
2. Trace yourself
3. Make a movie clip
4. Make it draggable
5. Slice yourself
6. Copy your script
7. Solve yourself!

PROCEDURE 1: IMPORT YOUR PICTURE

1. Scan a photo of yourself and save it on your hard disk. It shouldn't be a very high-resolution photo; an image that is 200 pixels high should be fine.

 If you don't have a photo of yourself to scan or if don't have a scanner, go to www.delmarlearning.com/companions/projectseries/ and download an image from there to your hard disk (downloading directions are on the Web site). Unless you're my niece Sarah, it won't be a photo of you, but it should do. If you are my niece, *hi Sarah!*

2. Start a new movie.

3. Go to the **File** menu and choose **Import.** A dialog box opens.

4. Use this file browser to locate your file. Click on the file name, then click **Open.**

 You can import several files at once by holding down the **Ctrl** key while you click on the file names.

5. Use the **Free Transform** tool 🔳 to resize the image so it takes up about one-quarter of the total frame, then drag the image toward one of the corners of the frame.

6. Click the **Arrow** tool 🔼 on a blank area of the frame to get the basic movie settings in the properties display.

7. Change the color of the movie background as shown in Project 1, Procedure 1 so that it is a color that you don't see in the image.

 If the background color is the same as a color in the image, then once you cut your picture apart, it may be hard to tell the edge of a puzzle piece from the background.

R
E
S
U
L
T

PROCEDURE 2: TRACE YOURSELF

1. Click the **Arrow** tool on the image to select it, then go to the **Modify** menu and choose **Trace Bitmap.** A dialog box appears.

2. Set the **Color Threshold** to **50.**

 This command breaks your image into areas of solid color. The threshold sets how wide a variety of colors in the original image can be combined into a single area and a single color. The lower the number you set here, the more complex (more and smaller areas) your image will be, and the larger your movie file will be.

3. Set **Minimum Area** to **20** pixels.

 This also keeps your image from becoming complex by limiting how small the smallest areas can be.

4. Set **Curve Fit** to **Very Smooth** and **Corner Threshold** to **Few Corners.**

 These settings keep your image not only simple but also graceful.

5. Click **OK.** Your photographic image is replaced by a series of colored areas that, combined, look like an artistic simplification of your photo.

 If the corners of your image disappear, go to the **Edit** menu, choose **Undo,** then repeat this procedure with a higher **Minimum Area** value.

A DEEPER UNDERSTANDING: BITMAP IMAGES

Digital photos and most computer art are stored as *bitmap* images (also called *raster* images). These rectangular images have specific information on what color goes in each pixel.

Flash treats a bitmap image as a totally separate item. You can rotate and scale it, but you really can't edit it the way you can edit something you drew in Flash. When you traced the bitmap, you converted it into a set of editable Flash shapes that you can do anything with.

RESULT

PROCEDURE 3: MAKE A MOVIE CLIP

1. Click on the movie's background. This causes the shapes to become deselected.

2. Click on one simple shape in your image. A dot pattern appears on the shape to show it is selected.

3. Drag the shape away from your image onto the background.

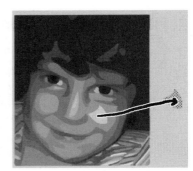

 Don't turn steps 2 and 3 into one step. If you try to drag the shape without having selected it first, Flash thinks you're trying to alter the shape.

4. From the **Insert** menu, choose **Convert to Symbol.**

5. In the symbol properties dialog box that appears, set **Behavior** to **Movie Clip** then click **OK.**

 A *movie clip* is the most complex type of symbol that Flash supports and can store an entire movie within it. That movie can contain sound, can be run separately, and can do other things that the other symbol types can't. Most important for this project is that a movie clip can be dragged. That is why you have made this a movie clip, even though it is a simple unanimated shape.

6. Double-click the shape. Flash enters symbol-editing mode for this new symbol.

7. From the **Insert** menu, choose **Convert to Symbol.** Set **Behavior** to **Button** then click **OK.** The shape is now a button *within* the movie clip!

 Tell a car to go to Nebraska and it won't go anywhere. Tell the *driver* inside the car "take the car to Nebraska" and the car will go there. A movie clip is like a car; just as a car can go to Nebraska, the clip can be moved during the movie, but it doesn't recognize when you try to drag it. The button inside the clip is like the driver in the car; the button understands what you are doing with the mouse and gives the needed command to the movie clip it is in.

PROCEDURE 4: MAKE IT DRAGGABLE

1. Open up the actions panel. Within the panel, open the **Movie Control** book as seen in Project 5, Procedure 4.

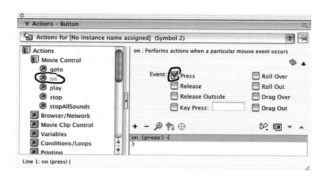

2. Double-click **on** on the list of actions. A list of mouse events appears at the right of the panel (in an area reserved for *parameters,* the options and variables of a command). Select the **Press** event option and clear any other options.

 The script in the lower right of the panel now reads *on (press) { }.* This means that whatever commands you put between the { } will run whenever someone points to this button and presses the mouse button down.

3. Open the **Movie Clip Control** book and double-click on **startDrag.** A startDrag command is added between the { }, which means that when the user presses the mouse button down on this button, the entire movie clip becomes draggable.

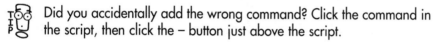 Did you accidentally add the wrong command? Click the command in the script, then click the – button just above the script.

4. Drag the **stopDrag** command from the list to the bottom of your script. Flash automatically guesses that you want to stop dragging when the mouse button is released and sets up the correct script for that. It is exactly the script you want!

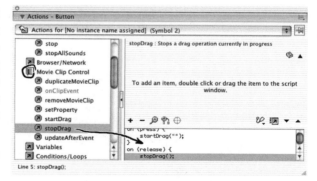

5. Close the actions panel as described in Project 5, Procedure 5.

 Don't see the entire script? Enlarge the panel by dragging the lower right corner.

RESULT

PROCEDURE 5: SLICE YOURSELF

1. Return to the main scene-editing mode by clicking **Scene 1** above the left of the stage.

2. Get the **Lasso** tool (short-cut: **l**) and draw a roughly circular path that contains a corner of your image. The portion of your image that is inside the path becomes selected.

3. From the **Modify** menu, choose **Group.** This tells Flash to treat everything you have selected (which may include portions of a number of shapes) as a single item. This makes the selection easier to move and to work with.

 A highlighting rectangle appears around the group. Don't worry, this doesn't mean that your group is now rectangular. It is still the same shape you selected.

4. Use the **Arrow** tool ⬉ to drag this group away from the rest of the image.

 If you group some things that you later decide shouldn't be grouped, select the group, return to the **Modify** menu, and choose **Ungroup.**

5. Use the steps from Procedure 3 to turn this group into a movie clip and then to turn it into a button within the movie clip. (Don't bother repeating Procedure 4. You'll set up the scripts for this button in Procedure 6.)

6. Repeat this procedure, cutting additional pieces out of your image. When there is just enough for one piece left, select the whole thing and do it again!

 Don't make the pieces too small unless you have a lot of time to work on the project. Ten pieces should be more than enough!

RESULT

PROCEDURE 6: COPY YOUR SCRIPT

1. Return to the **Scene 1** editing level. With the **Arrow** tool , double-click on the very first piece you took out of the image. The movie clip you made of it opens for editing with the button selected. Go to the **Window** menu and choose **Actions** to display the script you wrote for that button.

2. Click the list icon in the upper right of the actions panel and choose **Export As File** from the list that appears.

3. In the file browser that appears, type **dragger** as the name of your script then click **Save.**

4. Return to the **Scene 1** editing level and double-click on another movie clip. When you do this, the button in that clip is selected.

 Did you notice how when you're editing one clip the other clips look faded out? If you triple-click on one of the faded-out clips, Flash opens it for editing. Pause, then click once more to select the button for editing. This is a quicker way of doing step 4.

5. Click the list icon in the upper right of the actions panel and choose **Import From File** from the list that appears.

6. Use the file browser to locate and select **dragger** then click **Open.** The saved script is added to the current button.

 If Flash tells you that the script has errors, you're editing the wrong item. You either have the movie clip selected instead of the button in the movie clip, or you have gone into the button and are editing one frame of the button. Click **Scene 1** on the upper left of the editing window and double-click the piece to enter the movie clip. If the piece is not still selected, click on it. If Import From File is grayed out, click once more on the piece and try again.

7. Repeat steps 4 through 6 for all of the puzzle pieces.

RESULT

PROCEDURE 7: SOLVE YOURSELF!

1. From the **Control** menu, choose **Test Movie.** The movie opens up.

2. Try building the puzzle. Notice that the piece you are dragging doesn't always pass in front of the other pieces. Sometimes it passes behind the other pieces.

 The pieces have a natural stacking order, with the first pieces you cut from the image on the bottom of the stack. There are ways to work around this so that the piece you are dragging is always on top, but it would require more programming.

3. Close the test window.

4. Save the file. Name it **puzzle.**

5. Publish the movie as seen in Project 5, Procedure 8.

A DEEPER UNDERSTANDING: AIMING HIGHER

I hope you think this is a pretty nifty little project for the amount of work you have put in. Even when you are enjoying something, however, you should be thinking of how it could be better. Right now, you could do the exact same project again with a better picture and different-sized pieces (and it would be quicker to do this time, both because you now know what you are doing and because you already have the script so you wouldn't have to write it).

But what about more complex changes? Could you make the pieces actually snap together? Could you make it more like a jigsaw puzzle by making the pieces rotatable? Could you have a timer to let the user know how long finding the solution is taking? All of those things are possible if you learn enough about ActionScript. (One of them can be done without any additional ActionScript at all!) Whenever you learn a new feature of Flash, you should think about how you could have used that feature with the projects you have already done.

PROJECT 7
SUNSET

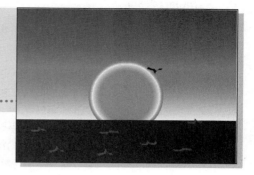

CONCEPTS COVERED

- ❏ Designing gradients
- ❏ Softening edges
- ❏ Frame-by-frame animation
- ❏ Onion skin
- ❏ Motion paths

REQUIREMENTS

- ❏ A sunny disposition

RESULT

- ❏ A lightly animated view of a sunset

PROCEDURES

1. Make a gradient
2. Place the sunset
3. Make the sun
4. Soften the sun
5. Draw a bird
6. Flap your wings
7. Set the bird's path
8. Move the bird
9. Just add water

PROCEDURE 1: MAKE A GRADIENT

1. Start a new movie.

2. If you don't see a color mixer panel open on the screen, go to the **Window** menu and choose **Color Mixer**.

3. On the color mixer panel, set the **Fill Style** drop list to **linear**.

 The *linear* and *radial* entries on this list are *gradients*. A *gradient* is a fill design that fades from one color to another and then on to more. That describes a sunset perfectly!

4. On the panel is a display of the gradient with little squares with pointers beneath it. If there are more than two squares, grab one from the middle and drag it down. The square disappears. Repeat this until there are just two squares, one on each end of the line.

 If you don't have a square on one end of the line, drag one of the squares from the middle of the line to the end.

5. Click the square on the left end to select it as the current square.

6. Click the color picker button in the upper left of the panel. Select a dark red from the color selector that appears. The current square turns dark red.

7. Select the square at the right end of the gradient design. Using the color picker button, set that square's color to yellow. Your gradient design now fades from dark red at the left to yellow at the right.

 To pick from a wider range of colors, click the down arrowhead in the lower right of the panel. There you'll see a rainbow-colored square that you can click on to select the basic color, and a vertical stripe you click to set the brightness of the color.

8. Click just below the center of the gradient line. A third square appears.

9. Use the color picker button to set that square's color to pink. You now have a gradient that fades from dark red to pink to yellow, a nice sunset design.

 Do you want to save this gradient design for later reuse? Just click the arrow button on the upper-right corner of the fill panel and select **Add Gradient** from the menu that appears.

PROCEDURE 2: PLACE THE SUNSET

1. Get the **Rectangle** tool (shortcut: **r**) from the toolbox.
2. Set the **Stroke Color** to **No Color**.

> Don't worry about setting the fill color. When you designed your gradient on the fill panel, it automatically became your fill "color."

3. Drag a rectangle that covers the top two-thirds of your movie.

> You may need to zoom out so that you can see the top two-thirds.

4. Oh no! The sunset is *sideways!* It is as if instead of the sun setting in the west, it is setting on the right edge of the panel. You'd better repaint it. Grab the **Paint Bucket** tool (shortcut: **k**) from the toolbox.

> Flash assumes that you always want linear gradients in your shapes to run from left to right.

5. Point to the top of the sideways sunset, hold down the **Shift** key, and drag down the full height of the sunset. When you release, the sunset is redrawn in proper position.

> When you drag a gradient into place like this, Flash sets the gradient's changes along the line that you drag. Everything before where you started your drag becomes the color on the left of your gradient design on the color mixer panel. Everything after the end of your drag becomes the color from the right end of your design. Holding down the **shift** key ensures that the line you drag comes out perfectly vertical.

RESULT

Procedure 3: Make the sun

1. Go to the color mixer panel and set the **Fill Style** drop list to **Radial.** The gradient design remains the same, but if you click the arrowhead in the lower right to see the expanded panel with the gradient preview, you'll see a circular design. That is what a *radial gradient* is: a gradient that starts with a single point of color, which fades into other colors in ever-expanding circles.

2. Set the center square's color to orange. The gradient now fades from dark red to orange to yellow.

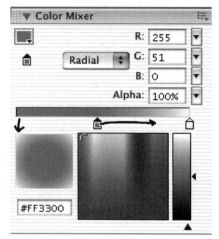

3. Drag the dark red square down to delete it. Everything to the left of the center point is now a solid orange, matching the first square. On the right side, the gradient fades to yellow.

4. Drag the orange square to the right so that four-fifths of the gradient is solid orange.

5. Get the **Oval** tool □ (shortcut: **o**) from the toolbox. Set the **Stroke Color** /■ to **No Color** ☑ .

> Why set the stroke color again when you already set it the same way before dragging the sunset onto the frame? Because when you select a tool that doesn't use the stroke (such as the paint bucket tool), the stroke color is automatically reset.

6. While holding down the **Shift** key (which makes the oval you drag a perfect circle), drag a circle into place in the center of your image. Make it about half the height of your sunset and have the lower edge go below the bottom of the sunset so that part of the sun is below the horizon.

PROCEDURE 4: SOFTEN THE SUN

1. Click the **Arrow** tool (shortcut: **v**) on the sun to select it.

2. From the **Modify** menu, choose **Shape, Soften Fill Edges.** A dialog box appears.

3. Set **Distance** to **20, Number of steps** to **8,** and **Direction** to **Expand.**

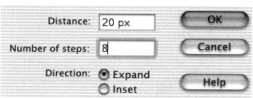

When the dialog box opens, if the distance unit is not listed in terms of *px* (pixels), click **Cancel** to leave this dialog box; click the blank area below the sunset, then click the **Size** button on the properties display and set **Ruler Units** to **Pixels.** Then go back to step 1 and try again.

4. Click **OK.** The sun expands 20 pixels in all directions, fading the yellow color at the edge out to the background color. Unfortunately, it doesn't fade it out to the sunset colors that surround the sun. Instead, it fades it out to the movie's background color, which created an unwanted halo around the shape.

Don't worry if the halo looks black. That's just showing that the object is selected. The proper color will appear when you deselect it.

5. Click the open area below the sunset to display the basic movie settings in the properties display. Set the **Background** to pink and set the **Frame Rate** down to **6 fps.** The open areas of your image as well as the halo around the sun are now pink.

Of course, if you wanted a pink halo, you could have simply made pink part of the color of your radial gradient. If you had done that, however, you wouldn't have learned about softening fill edges, which works even if your shape doesn't have a radial gradient. This is one of those cases where I have needlessly complicated your life simply to try to teach you a lesson!

RESULT

PROCEDURE 5: DRAW A BIRD

Options

1. From the **Insert** menu, choose **New Symbol.** When the dialog box appears, enter **bird** in the **Name** field and set **Behavior** to **Graphic** then click **OK.**

2. Get the **Brush** tool and set the **Fill Color** to black.

3. In the options area of the toolbox, click the **Brush Size** droplist and select the third smallest brush size (the third circle from the top). From the **Brush Shape** drop list, select a diagonal line.

4. Use this brush to paint a short rounded M shape in the center of the editing area. This is a distant seagull.

5. On the timeline, click frame **2.** From the **Insert** menu, choose **Blank Keyframe.** The seagull disappears because you're editing a new, blank frame.

6. Just below the **Timeline,** click the **Onion Skin** button. A faded version of the frame 1 seagull appears. It is not actually in the current frame. You are just seeing a faint image of the previous frame as a guideline.

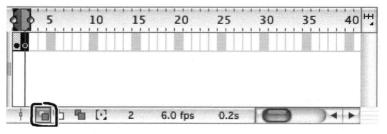

A DEEPER UNDERSTANDING: ONION SKIN?

Onion skin is the name of a type of paper, which, like the rind of a real onion, is thin and almost transparent. Because of the transparency, it can be used as tracing paper.

R
E
S
U
L
T

Traditional animators often use tracing paper when doing the pencil versions of their character drawings. That way they can closely match the movement of the limbs to their position in the previous frame, even seeing through to the frame before that. The onion skin option in Flash gives you the same effect. You can also click the **Onion Skin Outlines** button (next to the onion skin button) to see only the outlines of previous frames.

PROCEDURE 6: FLAP YOUR WINGS

1. Using the previous drawing as a guideline, draw the bird again. Put the wing tips at the same place but keep the wings lower and flatter, lowering the bird's center point slightly.

2. Insert a blank keyframe into frame **3.**

3. Draw the bird again, giving the bird more of a V shape, with the wing tips higher than before and the center point the same as in the previous panel.

4. Create a fourth blank keyframe.

5. Draw the bird again, keeping the wings as high as they were in the third frame, but a bit wider, while raising the body to where it was in frame 1.

 At the top of the timeline, you'll see rounded brackets on the number line. The brackets indicate which frames are being displayed through the onion skin. By default, Flash only displays three frames at a time, so you'll have to drag the left bracket more to the left to include frame 1. Even if you do, however, you'll have trouble seeing frame 1 because the bird drawings are right on top of each other.

. .

A DEEPER UNDERSTANDING: FRAME-BY-FRAME ANIMATION

Automated tweening is fine for simple motions but you can create more delicate and subtle movement by redrawing each frame. Look at the animation you just created: frames 2 and 3 aren't just intermediary points between 1 and 4, so tweening could not have done this.

You can still use shortcuts, not hand-drawing every frame of your movie. You just created what animators call a *cycle*. That means that you can run these same four frames repeatedly, creating a continuous movement.

RESULT

PROCEDURE 7: SET THE BIRD'S PATH

1. Click **Scene 1** in the upper left to return to the main scene, then click the **Onion Skin** button to turn off the onion skin feature.

2. Insert a new layer and name it **The bird.**

3. From the **Window** menu, choose **Library** to open the library.

4. Drag **bird** from the library onto the stage, putting it at the right side, just above the height of the sun.

5. From the **Insert** menu, choose **Motion Guide.** A new layer named *Guide: The bird* appears.

6. Get the **Pencil** tool and in the options area set **Pencil Mode** to **Smooth.**

7. Draw a rough oval starting at the body of the bird, going to the left, down so it touches the edge of the sun, back right, and up a little. Don't close it up—make the end of the line close to the start but not quite touching it. This is the path the bird will follow when it flies.

8. Select frame **24** of the guide layer and insert a new frame into it (from the **Insert** menu, choose **Frame**).

9. Select frame **24** of **Layer 1** and insert a new frame into it.

R
E
S
U
L
T

PROCEDURE 8: MOVE THE BIRD

1. Select frame **24** of the layer **The bird** and insert a new keyframe into it (from the **Insert** menu, choose **Keyframe**).

2. In frame 24, use the **Arrow** tool 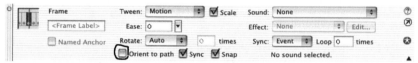 with the **Snap to Objects** option to drag the bird symbol to the other end of the line you drew. As you drag it, you will see a circle on the bird shape; get this circle right over the end of the line and the symbol should snap into place.

3. Select frame **1** of this layer.

4. From the **Insert** menu, choose **Create Motion Tween**.

5. Make certain that the **Orient to path** option is not selected on the properties display. (If you don't see this option, click the arrowhead in the lower right of the properties display to expand it.)

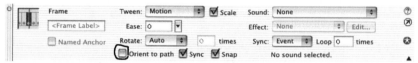

6. Press the **Return** or **Enter** key to test the animation. If all was done right, the bird should flap around the path.

 If the bird flaps once then stops, select the bird in frame 1 and switch the lower drop list on the properties display to **Loop**.

7. Go to the **Control** menu and choose **Test Movie** to see the bird fly the path repeatedly. Notice that the path line does not show up when the movie is viewed through the viewer. It is only visible in the editing window.

 Do you want to hide the line in the editing window as well? Click on the first of the two dots on the layer's timeline entry, just to the right of the layer title. An X replaces the dot, indicating you have hidden that layer.

8. Close the viewer window.

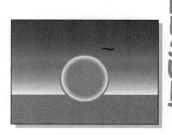

PROCEDURE 9: JUST ADD WATER

1. Select the **Guide: The bird** layer on the timeline.

2. Insert a new layer and name it **The sea.**

3. Use the **Rectangle** tool ☐ to drag into place a dark blue, strokeless rectangle that covers everything from the bottom of the sunset down.

4. Drag **bird** from the library window onto the sea.

5. From the **Modify** menu, choose **Transform, Flip Vertical.** The bird turns upside down.

6. On the properties display, set the **Color** drop menu to **Tint,** and set the **Tint Color** to a light blue. If you test the animation now, you'll see that this inverted bluebird looks like a little wave in the sea!

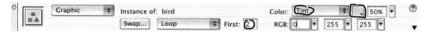

7. Get the **Arrow** tool ![arrow]. While holding down the Macintosh **option** key or the Windows **Alt** key, drag the wave to a new location. This will create a copy of the wave, a new instance of the same symbol.

8. Open the **Instance** panel and change the **First** setting to **2.**

This setting starts the animation of the second wave at the symbol's *second* frame so it doesn't look unnaturally synchronized with the first wave.

9. Repeat steps 7 and 8 to create additional waves, randomly mixing **First** values from 1 through 4 (because the symbol only has four frames).

10. Test and save the file.

R
E
S
U
L
T

PROJECT 8

DIRECTIONS

CONCEPTS COVERED

❏ Breaking apart bitmaps
❏ Path orientation
❏ Printing from Flash
❏ Printing from Flash player
❏ Exporting an image

REQUIREMENTS

❏ A map (can be scanned from this book or downloaded)

RESULT

❏ A map with a moving arrow showing directions

PROCEDURES

1. Get a map
2. Create an inset
3. Show the directions
4. Inset directions
5. Save a JPEG snapshot
6. Set up printing
7. Print
8. Give users a printable map

Procedure 1: Get a map

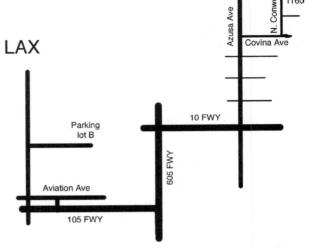

1. Get a graph-
ics file with a
picture of a
map in it. You
can scan the
map off this
page (I sug-
gest scanning
at **300** dots
per inch with
a **Grayscale**
setting), or
you can
download it
from www.delmarlearning.com/companions/projectseries/
(there are downloading directions there). You can use your
own map rather than using mine; just pick a map with a route
you want to highlight.

2. From Flash's **File** menu, choose **Open.** A file browser appears.

3. Set **Files of type** or **Show** to **All Files.**

 You'll be opening the map file directly. While Flash understands a
range of still graphic formats, it doesn't consider them movie formats
and doesn't usually list them as openable files.

4. Using the file browser, locate the map file. Click the file name
to select it then click **Open.**

5. Get the **Zoom** tool 🔍 (shortcut: **z**) with the **Reduce** option 🔍 .
Click on the staging area until you can see the entire map.

At the high resolution of the map image, the map takes up many more
pixels than the movie frame. It is covering up the movie frame so you
can't even see the edges!

6. Use the **Free Transform** tool ⊞ to reduce the map so it
fits in the frame.

7. From the **View** menu, choose **Magnification, 100%.** The
window returns to its normal magnification.

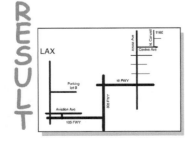

PROCEDURE 2: CREATE AN INSET

1. With the map image still selected, go to the **Edit** menu and choose **Copy.**

 The shortcut for this is to hold down the Windows **Ctrl** button or the Mac ⌘ button and press **C.** This is the same shortcut you would use for this command on your word processor, paint program, or on almost any other program you can name. The shortcuts for pasting and cutting are also consistent between programs.

2. Create a new layer and name it **Inset.**

3. Go to the **Edit** menu and choose **Paste** to place a copy of the map on this new layer.

4. From the **Modify** menu, choose **Break Apart.**

 This command tells Flash that you want to be able to cut pieces out of this bitmap.

5. Using the **Lasso** tool 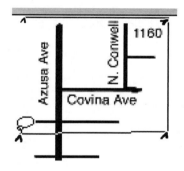 (shortcut: **l**) with the **Polygon Mode** option , click a series of points around the last turn or two of your route. When you click, it is as though you're setting down fence posts. When you get back to the first fence post, double-click on it. Flash connects the posts with fences and everything within the fence is selected.

 If this doesn't work, turn off the **Polygon Mode** option. Hold down the Windows **Alt** or Macintosh **Option** key while clicking the fence posts. Release the key and the area is selected.

6. Drag the selected area away from the rest of the map. It is now a separate object.

7. Click on the rest of the map then press the **Delete** key. The rest of the map on this layer disappears (although the whole original map is still underneath it).

8. Drag the inset to some part of your map where it won't overlap the route you want to highlight.

9. Using the **Free Transform** tool , drag the corner of the inset to enlarge it as much as you can without blocking the route you wish to highlight.

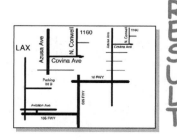

RESULT

PROCEDURE 3: SHOW THE DIRECTIONS

1. Create a new layer named **Route.**

2. On that layer, use the **Brush** tool with a red fill color to draw a little arrow at the very start of the route you want to display, pointing in the direction of your route.

3. Convert that arrow into a graphic symbol as in Project 1, Procedure 5. Name the symbol **Arrow.**

4. As you did in Project 7, Procedure 7, create a motion guide for your arrow. The path it follows should be your route on the map. I'll leave it up to you to decide what your final frame number should be for this; just remember what your frames per second rate is (it is displayed under your timeline) and multiply that by however many seconds you want the arrow to take to cover your route.

> For drawing paths along straight roads, you should use the **Line** tool 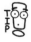 (shortcut: **n**), dragging along the roads and releasing at each turn.

5. As you did in Project 7, Procedure 8, attach the arrow so that it follows that path. You will need to do two things differently. First, when you place the arrow at the end of the path, use the **Free Transform** tool ⊞ to turn the arrow in the direction that the driver will be moving at the end of your path. Second, select frame **1** of the Root layer then on the properties display select the **Orient to path option,** which will make your arrow turn to follow the direction of the path.

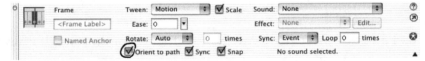

> Don't add the additional frames to your inset and map layers until after you have set the path and tested the animation. That way you can check your animation without the background clutter.

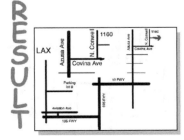

PROCEDURE 4: INSET DIRECTIONS

1. Select the **Guide: Route** layer and use the lasso tool to reselect the same area you selected in Procedure 2. This time you are not selecting the map, just the portion of the route that covers it.

2. From the **Edit** menu, choose **Copy** to copy this route to the clipboard.

3. By clicking on various frames on the timeline and seeing where the arrow is, find the frame where the arrow reaches the portion of the map that is enlarged in the inset.

4. Insert a new layer named **Inset route.** On this layer, insert a keyframe for the frame number you located in step 3.

5. Open the library and drag the arrow from there to where the path starts on the inset map. Rotate the arrow so that it points in the correct direction and enlarge slightly.

6. From the **Insert** menu, choose **Motion Guide.**

7. From the **Edit** menu, choose **Paste.** The route section you copied appears on the screen.

8. Use the **Free Transform** tool 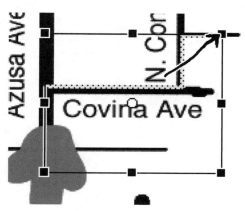 to move and resize this route section so that it covers the correct route on the inset.

9. As you did in Procedure 3, make the last frame of the **Inset route** layer a keyframe, move the arrow to the right position and orientation in that frame, then create a tween animation, moving the arrow along the inset path. Now not only does the arrow trace a path on the main map, but when it reaches the area that the inset map covers, the inset also has an arrow!

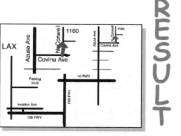

RESULT

PROCEDURE 5: SAVE A JPEG SNAPSHOT

1. Save the movie.

2. Select the frame where the arrow first appears on the inset.

> **TIP** It doesn't matter what layer you select this on. As long as it is selected on any layer, the saved image will be of this frame.

3. From the **File** menu, choose **Export Image.** A file browser appears.

4. Use the browser to go into the directory where you want to store this image. In the **Save as** field, type a name for the image. Set the **Format** to **JPEG Image** then click **Save.**

> **TIP** There are a number of image formats that Flash can save the image to. Each has its own uses. For example, you can save to the Adobe Illustrator format, which is handy if you have the Illustrator software and want to use it to create an enhanced version of the image.

5. A dialog box of settings appears. Make sure **Include** is set to **Minimum Image Area.**

> **WHY** This option elimi- nates the empty background from the edges of the saved image, creating a smaller image without losing anything of importance.

6. Set **Quality** to **80** then press **OK.**

- -

A DEEPER UNDERSTANDING: JPEG QUALITY

The Joint Photographic Experts Group (JPEG) format is designed for reducing the file size of digital photos while keeping good images. The amount of compression is variable; set the quality value to a low number like 10, and you end up with areas that look crusty and miscolored. Set a high number such as 90 and you will have a bigger but better-looking file.

For images with few colors and large open areas (such as my example map), the PNG and GIF formats are actually better than JPEG at making small files with clear reproduction.

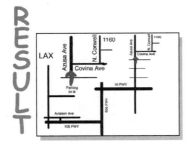

RESULT

PROCEDURE 6: SET UP PRINTING

1. Go to the **File** menu and choose **Page Setup.**
2. Set the paper orientation so that paper is wider than it is tall. The exact method for doing this depends on your operating system and printer. Most will either have a picture of the orientation to choose from, or have a **Landscape** option, which is what you want.
3. If you're using a Windows machine, click ahead to step 6.

 The print options on the Macintosh are divided between two different commands, whereas the Windows version has all the options in one command.

4. Click **OK** to close the page setup dialog box.
5. From the **File** menu, choose **Print Margins.** A dialog box appears.

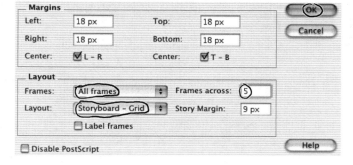

6. Set the **Frames** droplist to **All frames** so that you print out every frame of your animation.

 Choosing **First Frame Only** would print out just the first frame of each scene. Because there is only once scene in this animation, all you would get is a printout of one frame. In this case, that could be quite handy, giving you a printout of the map.

7. Set the **Layout,** to **Storyboard—Grid,** so that the frames print out in several rows of frames per page. When you choose this, some more fields become available. Set the **Frames across** field to **5** so that there will be five frames per row on the page.

 You don't have to set the number of rows per page. Flash reduces the frames so that it can fit those five frames per row on the page, then it fits as many of those rows on each page as it can.

8. Put a check in the **Label Frames** check box so that each frame is printed with a scene number and frame number then click **OK.**

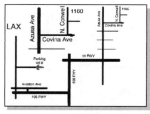

PROCEDURE 7: PRINT

1. Open the **File** menu. If you're using a Macintosh, choose **Print** then in the dialog box that appears, click **Preview**. If you're using Windows, choose **Print Preview.**

2. A window appears, displaying how the first page will look when you print it. Use the **Next Page** or **>** button to flip through the pages to make sure they look right.

3. Click the **Print** button if you have one, or go to the **File** menu and choose **Print**. A dialog box appears.

4. Click the **Print** or **OK** button. For some of you, that will be two Print buttons in a row. Alas, button designers today just don't have any imagination! Still, they do their work well so pages should soon be spilling out of your printer.

A DEEPER UNDERSTANDING: PRINTING ONE FRAME

As mentioned above, you can choose to reprint just the first frame of each scene. But what if you don't want the *first* frame? What if you want the thirty-ninth frame?

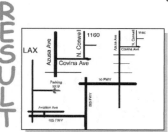

That's easy. When setting your frames and layout options (as shown in Procedure 6), set **Frames** to **All Frames** and **Layout** to **Fit On One Page.** That way, Flash wants to print every frame, one per page, enlarging the frame to fill up the page. Then when you get to the print dialog box, in the **Pages** area set **From** to **39** and **To** to **39.** Flash thinks of your whole document as a series of one-frame pages, and only prints the thirty-ninth of those pages—the one with frame 39!

PROCEDURE 8: GIVE USERS A PRINTABLE MAP

1. On the timeline, select the last frame of the **Inset Route** layer.
2. On the properties display, type **#p** into the **<Frame Label>** field.

 The *#p* label is a special label that means *make this frame printable.* Oddly enough, until you make a frame printable, Flash assumes that all frames are printable, and when someone viewing your movie tries to print it, every frame prints out. But once you make one frame printable this way, Flash assumes that all the other frames are unprintable.

3. Save the movie.
4. From the **File** menu, choose **Publish Preview, HTML.** Flash publishes a copy of your movie and opens it in a Web browser.

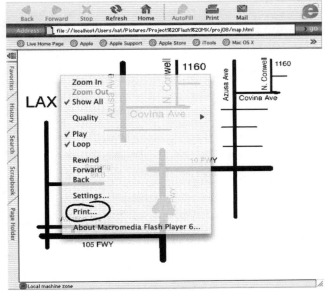

5. If you're using a Windows computer, right-click on the movie in the Web browser. If you're using a Macintosh, hold down the **ctrl** button and click on it. A menu appears.

6. Choose **Print** from this menu then use the dialog box that appears to set the print settings and start the printing.

7. Take the printout, fold it into a paper airplane, and throw it at someone who you want to come visit you.

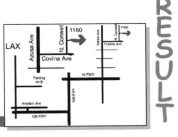

RESULT

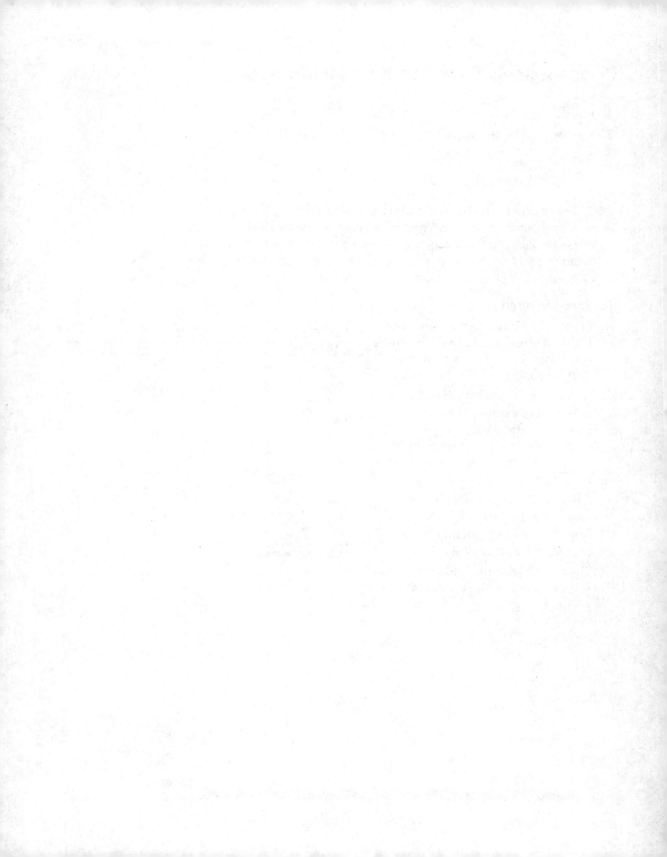

PROJECT 9

A PAGE OF WEB LINKS

CONCEPTS COVERED

- ❑ Grid
- ❑ Text hyperlinks
- ❑ Button hyperlinks
- ❑ Duplicating symbols
- ❑ Editing multiple frames
- ❑ Rotating symbols

REQUIREMENTS

- ❑ The results from at least two previous published projects such as the rain animation from Project 5, the puzzle from Project 6, or the map from Project 8. You can also publish the sunset from Project 7 and use it if you wish.

RESULT

- ❑ A menu page that links to your other projects

PROCEDURES

1. Turn on the grid
2. Make a menu item
3. Add button effects
4. Place the menu item
5. Make a similar menu item
6. Make different menu items
7. Add some text
8. Dance, letter, dance!
9. More dancing letters: YAY!
10. Put it to the test

PROCEDURE 1: TURN ON THE GRID

1. Start a new file, **550** pixels × **400** pixels, with a black background.

 Black is often a good background choice. Bright colors against a black background stand out and look sharp. You should avoid the black background if you are presenting a large amount of text to read. With lots of text a very light or white background is generally the best choice.

2. From the **View** menu, choose **Grid, Show Grid.** A grid work of lines appears in the stage.

 Don't worry; these lines aren't actually in your movie. They are just there to give you guidelines, making it easier to line up parts of your movie. Think of it as though you're viewing your movie through a screen door.

3. From the **View** menu, choose **Grid, Snap to Grid.**

 This command makes lining things up very easy. Now, whenever you draw or drag something into place near a grid line, Flash will adjust what you are placing so that it is actually on the grid line.

A DEEPER UNDERSTANDING: GRID SETTINGS

If you go to the **View** menu and choose **Grid, Edit Grid,** a dialog box of grid settings appears. There you can set the spacing between the gridlines and the color of the lines. Adjust the **Snap accuracy** setting to change how close you have to be to a gridline before Flash decides to snap your item to that line.

RESULT

PROCEDURE 2: MAKE A MENU ITEM

1. From the **Insert** menu, choose **New Symbol.** In the dialog box that appears, set the name to **Menu item 1** and the **Behavior** to **Button** then click **OK.**

2. Get the **Rectangle** tool □ . Set the **Fill Color** to black, the **Stroke Color** to a bright yellow, and the **Stroke height** to **1.**

3. In the center of the stage is a little crosshair, which is right on the intersection of two gridlines. Drag a rectangle that includes four squares of the grid just above the crosshair, two to the left of the crosshair and two to the right.

4. Click **Swap Colors** ⮂ in the toolbox to make your fill color yellow.

5. Get the **Text** tool A . Set **Font height** to **14,** then go to the **Text** menu and choose **Align, Align Center.**

6. Point to the bottom-left corner of your yellow rectangle, about one-quarter of the height from the bottom, and drag to the bottom-right corner.

7. Type a name for one of your existing projects such as **thunder.**

8. Drag across the name you typed. It becomes highlighted.

9. On the properties display click open the **Font** drop list. A list of font names appears. Let the pointer rest on a font name for a second, and a display shows what the word you typed looks like in that font. When you find a font you like, click it to set that font.

RESULT

PROCEDURE 3: ADD BUTTON EFFECTS

1. On the timeline, select the **Over** frame and insert a keyframe into it.

2. Use the **Arrow** tool to click on an empty area of the stage to deselect all the items that were automatically selected when you created your keyframe.

> Otherwise, when you do the next step, it will change the colors of the selected items.

3. Click **Swap Colors** to set the stroke color to yellow, then set the **Fill Color** to dark red.

4. Use the **Rectangle** tool to drag a red and yellow rectangle exactly over the existing black and yellow one. The text pops back in front of the rectangle.

5. On the timeline, select the **Hit** frame and insert a keyframe into it.

> This defines the active area of the button, used to tell when the pointer is pointing to it or clicking on it. Doing this now locks the current button shape in as the active area. This way, the material you add in the next few steps won't be considered part of the active area.

6. On the timeline, select the **Over** frame. Deselect everything as you did in step 2.

7. Click **Swap Colors** to set the fill color to yellow.

8. Using the **Text** tool , drag another text area as you did in Procedure 2. Start it one full grid block to the right of the previous text area and make it 6 blocks wide.

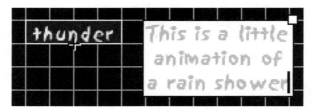

9. Type a description of the project whose name is placed on the button. Make the text several lines long. When you hit the end of the first line, the text box automatically expands for the next line.

RESULT

PROCEDURE 4: PLACE THE MENU ITEM

1. Click on **Scene 1** above the left of the stage to return to editing the scene.

2. Open the library and drag **Menu item 1** from the library toward the upper left of the frame, about two grid blocks down from the top and two blocks in from the left. Release the mouse button and your symbol appears.

3. With the **Arrow** tool selected, use the cursor keys to adjust the position of your button so that the upper-left corner of the yellow button outline is at the intersection of the second horizontal line from the top and the second vertical line from the left.

> **TIP** The cursor keys serve as very precise moving tools, moving the object one pixel in the cursor key's direction. This usually works even if you have another tool besides the arrow selected, but it doesn't work if you have the text tool selected.

4. As you did in Project 5, Procedure 4, open up the actions panel and select an action for this panel. In this case, you want to open the book **Actions** and within that, the book **Browser/Network**. Double-click the action **getURL**. When this action appears in the script window, it already includes the *on (release)* command that makes this command work when you click the button.

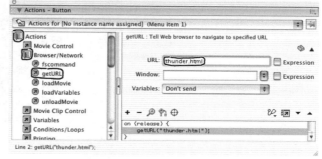

> **WHY?** URL is short for *Uniform Resource Locator*, a fancy term for a Web page address. This command makes the button a link to a Web page.

5. In the settings at the right of the panel, set **URL** to the name of the HTML file you created when you published the project.

> **TIP** If you don't know the name of the HTML file, open the old project, go to the **File** menu, and choose **Publish Preview, HTML.** Copy the file name from your Web browser's address field.

RESULT

PROCEDURE 5: MAKE A SIMILAR MENU ITEM

1. In the library, select **Menu item 1** by clicking on it.

2. Click the list icon in the upper right of the library window and choose **Duplicate** from the menu that appears. When the symbol properties dialog box opens, set **Name** to **Menu Item 2** and click **OK.** You now have two identical symbols, which is different from having two instances of the same symbol in your movie.

3. Double-click the icon next to **Menu item 2** in the library. The symbol opens up for editing on the stage.

4. Click the **Edit Multiple Frames** button on the timeline. Brackets appear around the names of the frames. If the right bracket isn't already on the right side of the **Hit** frame entry, drag it there.

5. The stage now displays all of the contents of all three keyframes of this symbol. Using the **Arrow** tool, drag a rectangle that encloses the project name button without touching

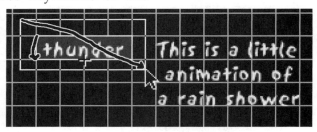

any of the project description. The project name button is selected. You can't see it but you have actually selected several versions of the button, as Flash has stacked the buttons from the up, down, and hit frames right on top of each other.

6. Point to the upper-left corner of the button and drag it down to the next grid block.

 The grid does not automatically snap the *edges* of your item to the grid. Instead, it snaps *whatever point you are dragging* to the grid. By starting with the corner of the item, you can place that corner right on a grid intersection.

7. Click the **Edit Multiple Frames** button again to turn the feature off. Only the up frame is now visible.

 You may need to click this button twice to get it to pop out.

Color scenes from the Projects

PROJECT 1: A SPOTLIGHT ON YOU

PROJECT 2: A VIRTUAL DRUM SET

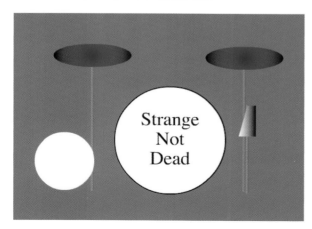

PROJECT 3: A LONELY RAINDROP

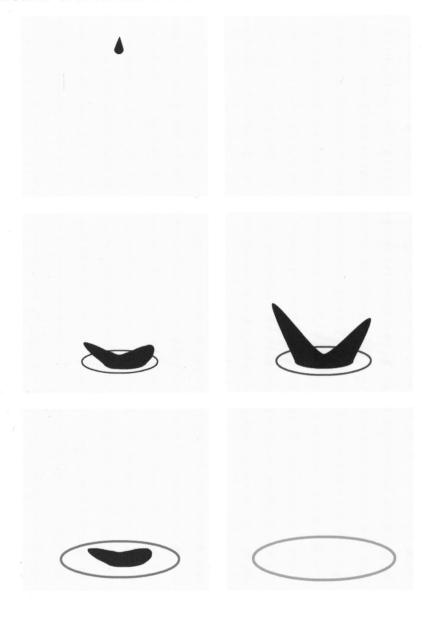

PROJECT 4: THUNDERSTORM!

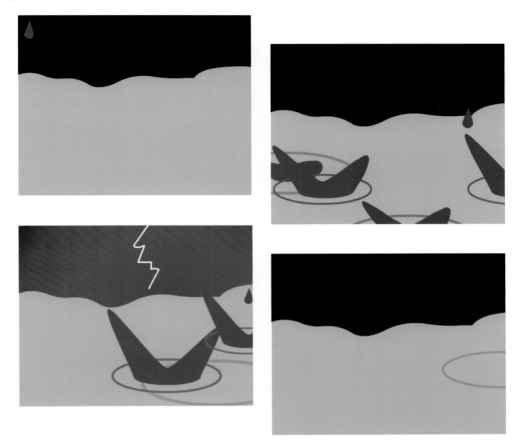

PROJECT 5: THUNDERSTORM ON THE WEB

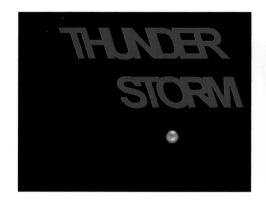

PROJECT 6: MAKE YOURSELF A PUZZLEMENT

PROJECT 7: SUNSET

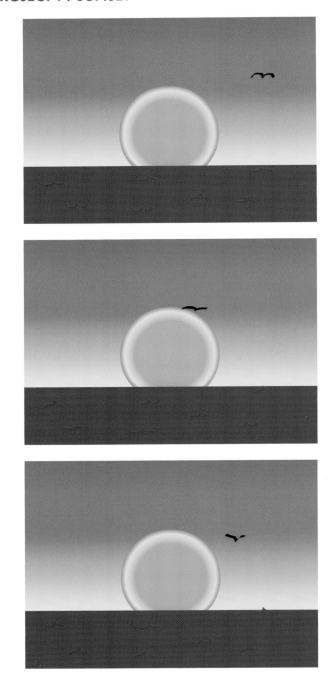

PROJECT 8: DIRECTIONS

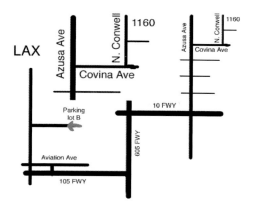

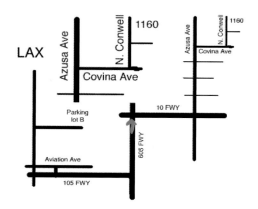

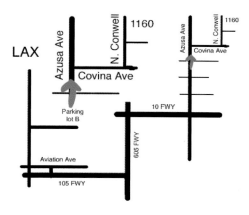

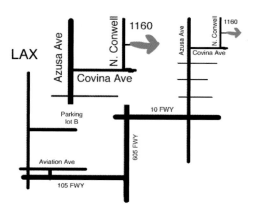

PROJECT 10: A BANNER AD

Looking for cartoon books?

Looking for cartoon books?

Looking for cartoon books?

Go

Go to

Go to AAUGH.com

PROJECT 11: BALLOON BA-BOOM! GAME

PROJECT 12: SUPER BALLOON BA-BOOM! GAME

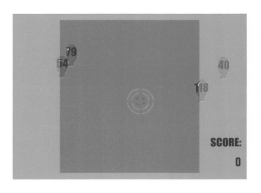

PROJECT 13: ULTIMATE BALLOON BA-BOOM! GAME

PROJECT 14: LICENSE PLATE MAKER

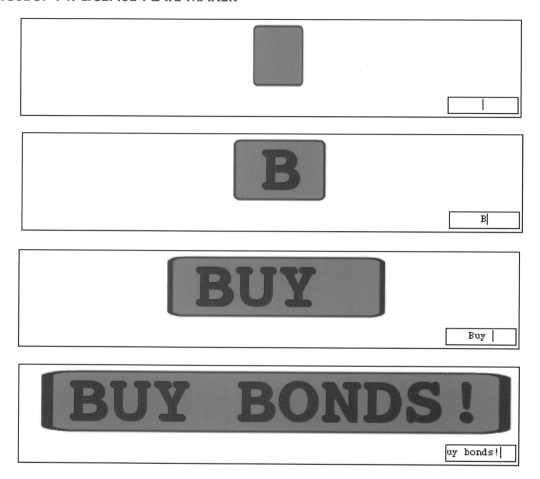

PROJECT 15: CUSTOM ALARM CLOCK

PROJECT 16: HEAD-BOPPIN' GUY

PROJECT 17: MUSIC VIDEO

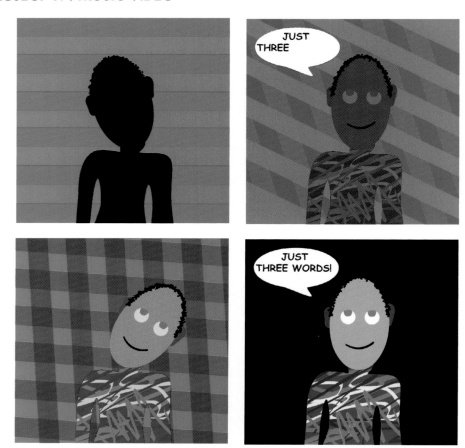

PROJECT 18: WEB-READY MUSIC VIDEO

PROJECT 19: AN ANIMATED BUSINESS CARD

PROJECT 20: CLOSING CREDITS

Directed by Nat Gertler
Produced by Nat Gertler
Written by Nat Gertler
Animated by Nat Gertler

Based on a concept by Nat Gertler
Casting by Nat Gertler
Catering by Nat Gertler

Starring (in order of appearance)

STICKGUY as himself

Music by Strange Not Dead

Absolutely no sticks were harmed

Starring (in order of appearance)

STICKGUY as himself

Music by Strange Not Dead

Absolutely no sticks were harmed
in the making of this movie.

Read the About Comics novel

COMING SOON: Stickguy 2

PROCEDURE 6: MAKE DIFFERENT MENU ITEMS

1. Using the **Text** tool A , drag across the button's text. Type the name of another of your published projects.
2. Select the **Over** frame and repeat step 1.
3. Use the same technique to replace the project description.

 Don't bother changing the button name on the hit frame. The hit frame only exists to track the shape of the button. The contents of the frame are never visible.

4. As you did in Procedure 4, add this button to your scene, placing it in the grid row immediately below the previous button. Link it to the appropriate project.
5. If you want the menu to include more of your projects, repeat Procedure 5 and this procedure. Each time, copy the previous symbol, lower the button in the symbol by one grid row, and then place the symbol one row lower on the scene.

 You are probably asking yourself "why do I bother lowering the button in the symbol every time? Why don't I spend my time on something more productive?" But what you're really lowering that button in relation to is the description. That way the description shows up in exactly the same place no matter which button the user points to. This makes it easier for the user (who doesn't have to refocus somewhere else on the screen) and you're saving screen space.

A DEEPER UNDERSTANDING: URLS

URLs can be very simple. If you are linking to another file that is stored in the same directory as your movie, the URL is simply the name of the file. If you're linking to a file on a different Web site, the URL can be long like *http://www.aaugh.com/guide/peanutsl.htm#work*. The best way to get the URL for a page on another site is to surf to that page, then copy the URL from the address field on your Web browser.

PROCEDURE 7: ADD SOME TEXT

1. On some otherwise unused area of your frame, use the **Text** tool [A] to add the phrase **Let's visit Carl!** in bright blue, using the font of your choice, with **Font height** set to **40.**

2. Double-click or drag across the word **Carl** in the text you just added to select it.

3. Expand the properties display to its full height and type **http://www.AAUGH.com/carl/** into the **URL link** field.

> This is how you turn text into a hyperlink to a Web page—just select the text and enter the URL of the Web page. It is a lot easier than linking a button to a Web page.

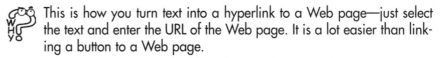
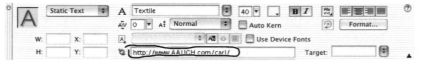

4. Go to the **Edit** menu and choose **Deselect All.**

5. Get the **Line** tool [/] (shortcut: **n**) from the toolbox. Click **Swap Colors** [↔] to set the stroke color to the color of the text.

6. From the **View** menu, choose **Grid, Snap to Grid.** The snapping feature turns off.

> The grid is handy when lining things up, but it is annoying to have it on when you want to draw something not on the grid.

7. Draw a line over the series of dots you see beneath *Carl.*

> The dots are there to let you know that Carl is a link. They will not be in the final movie. The person viewing your movie needs some way of knowing that Carl is a link, and underlining is a common Web method of indicating a link.

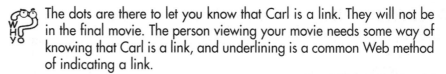

R
E
S
U
L
T

Let's visit *Carl!*

PROCEDURE 8: DANCE, LETTER, DANCE!

1. Select frame **10** on the **Layer 1** timeline and insert a frame there.
2. Add a new layer to your image.
3. Find a wide blank area and use the **Text** tool [A] to add a **Y** with a **Font height** of **50** in any color and any font you want.
4. Click the **Arrow** tool button [↖] to get out of text-editing mode with the text still selected, and go to the **Insert** menu and choose **Convert to Symbol.** Make the symbol a graphic.
5. Double-click the **Y** to start editing the new symbol.
6. Drag the **Y** a little in any direction. You just want to get it so that the crosshair is not in the center of the letter.
7. Insert a keyframe into the symbol's frame **10,** then go back to frame **1** and set up a motion tween.
8. On the properties display set **Rotate** to **CW** *(clockwise)* and **times** to **1.**

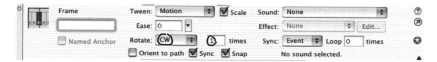

9. Click **Scene 1** to return to scene editing.
10. For the layer with the letter, set up the tween as you did in step 7, then set up a rotation as you did in step 8, only setting **Rotate** to **CCW** *(counterclockwise).*

If you test this now, you'll see the effect you've had. The rotation you set up for the entire symbol in step 10 would normally have the Y rotating around the off-center crosshairs. The rotation of just the letter (step 8) counters that, keeping the Y right-side up as it circles around the symbol's center point (the crosshair).

PROCEDURE 9: MORE DANCING LETTERS: YAY!

1. Repeat Procedure 8 to add a letter **A** to the right of the Y in a different font and color. Make it rotate in the opposite direction, by choosing **CW** where Procedure 8 says **CCW** and vice versa.

 Don't repeat Step 1, inserting a tenth frame into layer 1. The first time you did that made the animation of that layer 10 frames long. If you do it again, Flash thinks you want to insert a new frame in front of the current frame 10, extending the layer to last until frame 11.

2. Add another **Y** to the right of the **A,** using a different font and color and rotating in the same direction as the original.

 Resist the temptation to just copy the symbol for the first Y. If you did that, you would end up with the Ys moving synchronously. If you build a new Y, the two letters won't have the same distance from the center of their symbols. This will cause them to move in different-sized circles, giving the resulting animation a more random and lively look.

3. Add a **!** rotating in the same direction as the A. When you set up both rotations, set the **times** value to **2** instead of 1. This way the exclamation mark will move twice as fast as the letters.

PROCEDURE 10: PUT IT TO THE TEST

1. Save the file in the same directory where you have saved your other projects. Name it **menu.**

2. Publish and open your file by going to the **File** menu, **Publish Preview, HTML.**

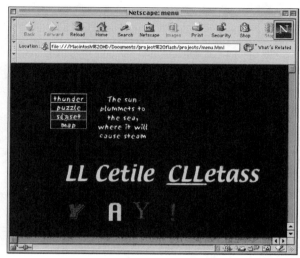

3. Take a careful look at your movie as it displays in your Web browser. It may have a major problem. The words *Let's visit Carl* may be all messed up. This is because your movie uses the text hyperlink feature introduced in Flash version 5. If your Web browser has an older version of the Flash player installed, it will still basically understand the program, but it will mess up any text boxes with hyperlinks in them. Go to **www.flash.com** where you can download the latest version of the Flash player.

4. Test your menu by running the pointer over the menu entries and watching the descriptions appear. Click on the menu items to test the links. When the links work, use the **back** button on your browser to return to this page.

 If a menu link doesn't work, you either made an error entering the URL for the link, or you didn't save the menu file in the same directory as the project you're linking to.

A DEEPER UNDERSTANDING: OLD FLASH VERSIONS

At this point, almost every Web browser in use has a Flash player installed. One-third of these people don't have the *latest* Flash player, but they have one that was devised for an earlier version of Flash. How can you make your site usable for these folks? You can go to the **File** menu, choose **Publish Settings,** and on the **Flash** tab set **Version** to **Flash Player 3.** Republish your movie and test it; if everything still works, then your movie is fine for almost every viewer. If it doesn't, switch back to a Flash Player 6 setting and put a note on your Web page that your movie requires Flash Player 6. Provide a link to www.flash.com so that the user can visit the site and download the current player.

RESULT

PROJECT 10
A BANNER AD

CONCEPTS COVERED

❏ Transparency
❏ Masks
❏ Creating animated GIF files

REQUIREMENTS

❏ The address of a Web site that offers something interesting

RESULT

❏ An animated banner ad for use on a Web page

PROCEDURES

1. Announce the product
2. Spotlight
3. Make a shadow layer
4. A mask for the spotlight
5. Spin an X
6. A slogan
7. Save the banner

PROCEDURE 1: ANNOUNCE THE PRODUCT

1. Start a new file, **468** pixels × **60** pixels, with a dark blue background and a **Frame Rate** of **12** fps.

 These are the pixel dimensions of the traditional standard Web banner ad, although it is losing popularity to a number of other ad sizes.

2. Get the **Text** tool A and set the font to **Arial** and the **Font height** to **47.** Set the fill color to any light color.

3. Drag the width of the panel, just a smidge above the bottom panel border. In the text box that appears, type **Looking for something?** but instead of **something,** type the name of something interesting that you can find on the Web. Don't worry if one word wraps to the next line.

4. Get the **Arrow** tool ↖ . The text box closes because you are done editing but the text is still selected.

5. On the properties display, click on the **Character Spacing** drop arrow and adjust the slider. As you do, the spacing between the letters changes. Find a tracking setting where your words all fit on one line but come close to taking up the full width of the banner.

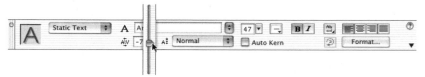

6. From the **Modify** menu, choose **Break Apart** to break the text into separate letters, then choose **Break Apart** *again* to turn the letters into a single shape.

 After this, you can no longer edit it as text (such as adding or deleting letters), but you can do things with a shape that you can't do with text, such as filling it with a gradient. This step won't work with some fonts.

7. Using the techniques from Project 7, Procedure 1 and Procedure 2, create a gradient fading from one bright color to another and fill the text shape with that gradient.

RESULT

PROCEDURE 2: SPOTLIGHT

1. Insert a new layer on top of the current one. Name it **Spotlight.**
2. Get the **Oval** tool ⬚ . Set the **Fill Color** ⬚ to white. Set the **Stroke Color** ⬚ to **No Color** ⬚ .
3. Drag a circle that is about twice as high as the banner.
4. Click the **Arrow** tool ⬚ on the circle to select it. Convert the circle to a graphic symbol.
5. Drag the circle to the left so that most of it is off the left of side of the banner, and it just overlaps the L in Looking.

> **TIP** You may need to scroll the window to be able to reach the left end, depending on the size of your editing window.

6. On the properties display set **Color** to **Alpha** then set the value field next to it to **25%**. The circle becomes mostly transparent.

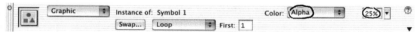

> **WHY?** The *Alpha* setting dictates how opaque something is. Usually you work with alpha at 100% so everything is solid. In this step, you make the spotlight circle see-through to show what is beneath the light.

7. Insert a frame into frame **20** of **Layer 1.** Insert a keyframe into frame **20** of the **Spotlight** layer.
8. Drag the circle to the right end of the banner.
9. Select frame **1** of the **Spotlight** layer and create a motion tween.

RESULT

Looking for cartoon books?

PROCEDURE 3: MAKE A SHADOW LAYER

1. On the timeline, click **Layer 1.** The entire layer (which is just the text) and all its frames become selected.

2. From the **Insert** menu, choose **Convert to Symbol** then choose to make it a graphic symbol.

 You are about to copy this layer. If you copied it without making the text shape a symbol, the copied layer would have a complete second copy of the text shape. By making the text a symbol, the two layers will both just have a pointer to the same symbol so the shape is only stored once. This saves file space. It really doesn't make a difference in this project because you're making an animation for a non-Flash format that won't be storing as much complex information. Still, it is a good habit to get into.

3. From the **Edit** menu, choose **Copy Frames.** All the information about the frames is copied onto the clipboard.

4. On the properties display set **Color** to **Brightness.** A value field appears. Set it to **–100%.** The text turns black.

5. From the **Insert** menu, choose **Layer.** A new layer appears.

6. Click on the name of the new layer. All of its frames are selected.

7. From the **Edit** menu, choose **Paste Frames.** This layer now has a copy of the text in full color.

R
E
S
U
L
T

Looking for cartoon books?

PROCEDURE 4: A MASK FOR THE SPOTLIGHT

1. Using the same technique you used in Procedure 3, copy the spotlight layer.

 You don't need to make the spotlight a symbol because it is already a symbol. And don't set the brightness effect either. That was just an additional thing you were doing while you were copying the layer.

2. If you are using a Macintosh, hold down the **ctrl** key and click on the name of the original spotlight layer. If you are using Windows, right-click on the layer name. In either case, a menu appears.

3. Choose the **Mask** command on this menu. Suddenly, the full-color text is only visible wherever the spotlight is. The dark text is seen everywhere else.

 This command turned the copied spotlight layer into a *mask layer,* and the layer below it became a *masked layer.* The entire masked layer is hidden *except* where you have something on the mask layer.

A DEEPER UNDERSTANDING: MASKS

A mask layer is merely a way of marking what parts of another layer should be visible. You can see the masked layer wherever a mask layer has anything on it. The rest of the masked layer is hidden.

It doesn't matter what color the items are on a mask layer or how transparent the items are. What matters is their shape. If there's anything there, the masked layer is visible. The contents of the mask layer aren't even shown as part of the animation. That is why you had to make a copy of the spotlight layer. The original layer shows the light of the spotlight, while the mask layer reveals what the spotlight is lighting up.

RESULT

PROCEDURE 5: SPIN AN X

1. From the **Insert** menu, choose **Scene.** A new blank scene appears.
2. Use the **Rectangle** tool to draw a white rectangle that completely and exactly covers the background.
3. Insert a frame in frame **36** of this layer.
4. Create a new layer.
5. Draw a red rectangle that is about one-quarter as high as the banner, running from off the left side of the frame to off the right side, placing it across the center of the banner.
6. Use the **Free Transform** tool to drag the rectangle while holding down the Windows **Alt** key or the Macintosh **Option** key. A copy of the rectangle appears.
7. Rotate the copy of the rectangle then use the **Arrow** tool ⟨arrow⟩ to move it so that it is perpendicular to the center of the first red rectangle.
8. Click in a blank spot to deselect the rectangle, then click on the rectangle again. Both red rectangles become selected.

> Flash has forgotten that these are separate items. Once two shapes touch, Flash treats them as a single shape.

9. Convert the rectangles into a graphic symbol.
10. Insert a keyframe into frame **36** of this layer. Return to frame **1** and create a motion tween, setting the red cross to rotate one time clockwise by using the techniques from Project 9, Procedure 8.

RESULT

PROCEDURE 6: A SLOGAN

1. Insert a new layer on top of the red cross layer.
2. Place a black rectangle on this layer that goes close to all four edges of the white rectangle, but not quite reaching the edges.

 As you drag the black rectangle, do the edges keep jumping to line up with the edges of the white rectangle? Choose **Undo** from the **Edit** menu to undo your rectangle placement, then go to the **View** menu and choose **Snap to Objects** to turn that feature off. You should have an easier time dragging the rectangle now.

3. Get the **Text** tool A and set **Character spacing** to **0** and click the **Left/Top Justify** button.
4. Add the word **Go** in red toward the left side of the black rectangle.
5. Insert a keyframe in frame **6** of this layer.
6. In frame 6, add the word **to** next to Go.

 Double-click the word **Go** and the text editing box reopens. You can type the word **to** in there and not have to worry about getting a second text box to line up with the first.

7. Insert a keyframe in frame **12** of this layer.
8. In frame 12, add the domain name of a Web site that offers what the text in Scene 1 asked about. Using the technique from Procedure 1, adjust the tracking on the domain name so it stretches almost to the end of the black rectangle. With the letters still selected, set the **Fill Color** ⬦■ to white.

R
E
S
U
L
T

Go to **A A U G H** . c o m

PROCEDURE 7: SAVE THE BANNER

1. Save the file. Name it **Banner.**

2. From the **File** menu, choose **Export Movie.** In the dialog box that appears, set **Format** to **Animated GIF.** Set **Save as** to **banner.gif** then click **Save.** Another dialog box appears.

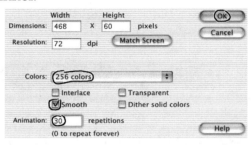

3. Set **Colors** to **256 colors,** select only the **Smooth** option, set **Animation** to **30** repetitions, then click **OK.** Your file is saved.

 Setting **Colors** to **Standard Colors** limits the image to a fixed set of 216 colors, which it knows any color computer can represent. However, precise color representation isn't very important here. Choosing **256 colors** lets Flash pick the colors that are most needed for this particular movie.

4. Use your Web browser to view banner.gif.

A DEEPER UNDERSTANDING: ANIMATED GIF FORMAT

The big advantages to using Animated GIF format to distribute ads all come from its ubiquity. All but the very earliest graphic Web browsers have had support for the format built in, so you know Web surfers can see the ad. Many of the places on-line that carry ads will only accept GIF ads, although Flash support is becoming more common.

The animated GIF format is fairly simple. The first frame is stored as a *Graphic Interchange File (GIF)* still image. For every frame after that, only the difference between the current frame and the previous frame is stored. In the first scene of this movie, for example, each frame has a picture of where the spotlight has moved to and the now-dark area where it has moved from because those are the parts that have changed.

Because of this, and because of the method of compression used, the animated GIF format is efficient at storing animations with big blocks of solid color and items appearing in place rather than moving, such as Scene 2 of the movie you just made. It is bad at subtle colors and big moving items as in Scene 1. Even though Scene 1 has fewer frames than Scene 2, it takes up about four times as much disk space, which makes it slow to download.

PROJECT 11

BALLOON BA-BOOM! GAME

CONCEPTS COVERED

❑ Shape tween guides
❑ Goto command
❑ Targets
❑ Drawing see-through objects
❑ Customizing the cursor

REQUIREMENTS

❑ None

RESULT

❑ A simple video game: click on a moving balloon, and it explodes

PROCEDURES

1. Make the balloon
2. Balloon popping
3. Highlight the button
4. Make the button a detonator
5. Move the balloon
6. Make crosshairs
7. Animate the crosshairs
8. Turn the crosshairs into the cursor

PROCEDURE 1: MAKE THE BALLOON

1. Start a new file, **550** pixels × **400** pixels, with **Background Color** set to sky blue and the **Frame Rate** set to **20** fps.

 For a video game, you want a quick frame rate so that the action appears to move smoothly. This has a downside, however; the faster the frame rate, the more likely it is that slower computers won't be able to keep up. Video games built in Flash use the processor and graphics systems less efficiently than standard commercially made video games and can't match their high level of complex moving detail.

2. From the **Insert** menu, choose **New Symbol.** Name the new symbol **Balloon** and set **Behavior** to **Movie Clip.**

 You'll want this symbol to have a sound in it. Unlike graphic symbols, movie clips can contain sounds that will be heard when the symbol is included in the movie.

3. Use the drawing tools to draw a brightly colored balloon, about the size of your thumbnail, on the first frame of the symbol. Don't have any stroke around it. The center of the balloon should be on the crosshairs at the center of the symbol.

4. Insert keyframes into frames 2 and 4 of this symbol.

 You'll be doing something special with frames 2 and 3, but you still want the balloon as it is in frames 1 and 4.

5. Click frame **2** on the timeline. The entire content of the frame, which is just the balloon, is selected.

6. From the **Insert** menu, choose **Convert to Symbol.** Set the **Name** to **Balloonbutton** and the **Behavior** to **Button.**

 This button is what the user will click on to blow up the balloon. The button is only in one frame of the symbol, but you'll see to it that that frame stays on-screen for a long time.

PROCEDURE 2: BALLOON POPPING

1. Select frame **9.** Go to the **Insert** menu and choose **Blank Keyframe** to have this frame set up as a keyframe without the image of the balloon in it.

2. Use the **Paintbrush** tool to draw a rough line around the crosshairs. The shape you draw should be larger than the balloon. This is the exploded balloon.

3. Use the **Arrow** tool to select the line you just painted, then click the **Smooth** option . The shape of the line smooths out a little bit.

> Repeatedly clicking the smooth option can smooth the line even more, although it may smooth it until parts of the line disappear entirely.

4. Select frame **4** on the timeline then open the properties display all the way. Set **Tween** to **Shape** and **Blend** to **Angular.**

Frame	Tween: Shape	Sound: None
<Frame Label>	Ease: 0	Effect: None Edit...
Named Anchor	Blend: Angular	Sync: Event Loop 0 times
		No sound selected.

5. From the **Modify** menu, choose **Shape, Add Shape Hint.** A lowercase A in a circle appears. This is a *shape hint*, a marker used to adjust shape transformations.

6. Drag the shape hint to the top of the balloon.

7. On frame 9, you will also find the shape hint symbol. Drag it onto the explosion line, to the furthest point above the crosshair. Now when Flash animates the balloon exploding, the top of the balloon will be headed to that point.

8. Select frame 4 again, then repeat steps 5 through 8, setting the hint at the bottom of the balloon and the lowest point of the explosion.

> Notice that the second hint has the letter *b*. You can use up to 26 hints, *a* through *z*.

9. Using the techniques from Project 3, Procedure 8, add a balloon-popping sound to frame 4.

RESULT

PROCEDURE 3: HIGHLIGHT THE BUTTON

1. Click the **Edit Symbols** button below the right end of the time-line, and choose **Balloonbutton** from the menu that appears. The stage now displays the button, which, because the button is an image of the balloon, is just like everything else we've done so far.

2. On the timeline, select the **Hit** frame and make it a keyframe.

 You want the hit area of the balloon to be the balloon shape, even though you'll add things in other frames.

3. Select the **Over** frame and make it a keyframe.

4. From the **Modify** menu, choose **Group.**

 Normally when you are drawing on a layer, Flash considers everything you are drawing to be part of a single group of shapes and lines, and anything you draw changes or adds to that group, sometimes destroying what you've made before. With this step, you told Flash that the balloon is its own group, which won't be changed by any further drawing you do. It is almost as if you had put the balloon on a separate layer.

5. Get the **Oval** tool and set the **Stroke style** to a dotted-line style, the **Stroke height** to **1,** and the **Stroke color** to the same color as the balloon.

6. Draw an oval with a white fill. Have the oval encircle the entire balloon. This oval appears behind the balloon rather than in front of it because the balloon is its own separate group.

PROCEDURE 4: MAKE THE BUTTON A DETONATOR

1. Click the **Edit Symbols** button below the right end of the time-line, and choose **Balloon** from the menu that appears. You are back to editing the movie clip.
2. Select frame **2** on the timeline. Use the **Arrow** tool to select the balloon button.
3. From the **Window** menu, choose **Actions** to open the actions panel.

 There is an arrow button on the properties display that opens up the actions panel with a single click.

4. Open the **Actions** book then open the **Movie Control** book within it. Double-click the **goto** command. Flash automatically assumes that you want this to happen when someone clicks on the button, so it puts the *goto* command (actually named *gotoAndPlay*) inside an *on (release)* command so it will be triggered when the mouse button is released.

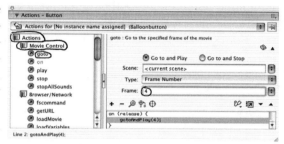

5. Set the **Frame** variable to **4** so that when you click on the button, the Balloon movie clip advances to frame 4, starting the explosion.

 Waitaminnit! Wouldn't the movie clip play frame 4 shortly after frame 2 anyway?!? Yes, it would, but you are about to add a command to avoid that situation.

6. Insert a new layer and name it **Actions.**

 When possible, have your actions on a separate layer. It makes it easier to find the actions when you need to adjust them.

7. Insert a keyframe into the third frame of the new layer.
8. On the actions panel, double-click the **Stop** action in the Movie Control book. The movie clip now stops when it reaches frame 3, displaying the balloon button until the user clicks it. When the balloon is clicked, the clip starts playing at frame 4.

RESULT

PROCEDURE 5: MOVE THE BALLOON

1. Test the Balloon movie clip by going to the **Control** menu and choosing **Test Scene.** You may need to expand the test window to see the whole balloon. Try hovering over the balloon and see it get highlighted. Try clicking the balloon and watch it explode. Close the player window when you're done.

 The usual Test Movie command won't work because you haven't created an instance of this clip in the movie yet. Because this clip has actions and other complexities, you can't properly test it on the stage by pressing Enter or Return.

2. Click **Scene 1** above the left of the stage to return to editing the scene.
3. Open the library and drag the **Balloon** symbol onto the stage.
4. Using the same techniques that you used to move the spotlight way back in Project 1, make the balloon float from side to side across the image over the course of 140 frames (that's 7 seconds).
5. Test the movie by going to the **Control** menu and choosing **Test Movie.** Click on the balloon as it floats by and watch it explode. Again, close the player when you're done.

R
E
S
U
L
T

PROCEDURE 6: MAKE CROSSHAIRS

1. Start a new movie clip symbol and name it **Crosshairs.**
2. From the **View** menu, choose **Grid, Edit Grid.** A dialog box opens.
3. Turn on the **Show Grid** and **Snap to Grid** options and set the **Width** and **Height** values to **10** pixels. Click **OK.**

4. Get the **Oval tool** ⬭ . Set the **Stroke style** to **Solid,** the **Stroke height** to **2,** the **Stroke color** to black, and the **Fill Color** to **None.**
5. Open the **Color Mixer** panel, click the left side of the **Stroke color** button 🖊■ , then set the **Alpha** value to **50%.**

> This alpha value is like the one you set in Project 10, Procedure 2. It changes the opacity of the color. By lowering it to 50%, the game player will be able to see through the crosshairs.

6. Create a circle that is two grid squares across, surrounding the crosshairs on the stage.

> If the grid is hard to see against the background color, repeat step 2. Click the **Color** button, choose a different color for the grid, then click **OK.**

7. Using this same technique, set the stroke color to a middle gray with 50% alpha and draw two more circles around the same center point, one 4 grid blocks across and the other 6 grid blocks across.
8. Get the **Eraser** tool 🖉 (shortcut: **e**) from the toolbox. Click the **Eraser Shape** button in the Options area, and choose the second smallest square from the list that appears.
9. Point to one side of the concentric circles you have drawn on the grid line that passes horizontally through the circle. While holding down the **Shift** key, drag to the other side of the circles. When you release, the area you dragged is erased.
10. Repeat step 9, dragging from top to bottom.

PROCEDURE 7: ANIMATE THE CROSSHAIRS

1. Insert a keyframe into frame 4.

2. Make sure the **Stroke Color** button ✎■ on the toolbox is pressed in.

3. Deselect the circle segments by going to the **Edit** menu and choosing **Deselect All.**

4. Get the **Dropper** tool ✎ (shortcut: **i**) and click on one of the black circle segments. When you do this, Flash takes the color you have clicked on (alpha settings and all) and makes it your stroke color. Not only that, but your current tool is automatically switched to the ink bottle tool 🍶 !

5. Click the ink bottle on the four segments of the outermost circle. They turn the current stroke color. The ink bottle is a cousin to the paint bucket tool; the ink bottle handles strokes while the paint bucket handles fills.

 > The pointer for the ink bottle tool shows some ink pouring from a bottle. You want to click the bottom point of that ink on the line you want to fill.

6. Get the **Dropper** tool back and click it on the medium-sized circle, then use the ink bottle tool to spread the gray color to the four segments of the smallest circle. Now you have a black outer circle with two gray circles inside.

7. Using the same techniques you used here, create a new keyframe in frame 7 and make the middle-sized circle black while the other two are gray.

8. Insert a frame into frame 9.

RESULT

PROCEDURE 8: TURN THE CROSSHAIRS INTO THE CURSOR

1. Return to editing the main scene and create a new layer above the existing layer. Name this new layer **Pointer.**

2. Use the **Arrow** tool to drag the **Crosshairs** symbol from the library and put it approximately in the middle of the stage.

3. With that instance of the symbol still selected, go to the actions panel, open the **Actions** book, then the **Movie Clip control** book, then double-click **startDrag**. The commands are set up so that this movie clip is draggable from the moment it is brought into the movie. That is what *onClipEvent (load)* means: that the startDrag command takes place when the clip event is loaded.

4. In the settings and options area of the panel, select the **Lock mouse to center** option.

This keeps the center of the crosshairs at the same spot as the active point on your mouse pointer. This way, when you move the crosshairs over a point, the circles are focused on the spot you are pointing to.

5. In the **Objects** book is a book named **Movie**, and in *that* is the **Mouse** book, and in that is a **Methods** book you need to open.

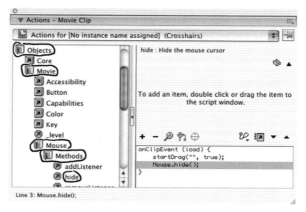

6. Double-click the **Hide** command. The command *Mouse.hide()* is added to the program you have built. Now when this movie clip is loaded, the usual pointer is hidden. When game players move their mice across the Flash display, their only mouse pointer will be your crosshairs!

7. Save your game with the name **Balloon.** Test your game. Okay, it's a *lame* game. There is no scoring, no end to the game, and the balloon keeps moving in the same direction and is easy to hunt. Wait until the next project, when you transform this game into one worth playing!

RESULT

PROJECT **12**
SUPER BALLOON BA-BOOM! GAME

CONCEPTS COVERED

❏ Variables
❏ Dynamic text fields
❏ Rulers
❏ Guides
❏ Dragging boundaries

REQUIREMENTS

❏ The Balloon Ba-boom game you made in Project 11

RESULT

❏ An enhanced game with multiple balloons, scoring, and more

PROCEDURES

1. Give the balloon a point value
2. Show the value on the balloon
3. Increase the point value
4. Stop the exploded balloon
5. Display the score
6. More balloons!
7. Create a shooting window
8. Set up guides
9. Outline the shooting window

PROCEDURE 1: GIVE THE BALLOON A POINT VALUE

1. Open up the Balloon game file you saved in Project 11.
2. Click the **Edit Symbols** button above the right of the stage and choose **Balloon** from the menu. The balloon movie clip is now on the stage.
3. Select frame **1** on the **Actions** layer then open the actions panel.
4. Open the **Actions** book and the **Variables** book within it, then double-click **set variable**.
5. Type **Points** into the **Variable** field, **10** into the **Value** field, and click the **Expression** option next to the Value field.

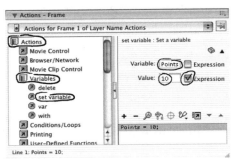

 You have just created a storage area in the computer, named *points*, and you have just stashed the number 10 in there. You chose the Expression option because you wanted to store a number.

. .

A DEEPER UNDERSTANDING: VARIABLES

Variables are named areas of memory where Flash keeps track of things that you ask it to keep track of. Here you created a variable named *points* to keep track of how many points the balloon is worth. Later, you'll create a variable named *score* to keep track of the player's total score. Whenever a balloon is popped, the value of *points* will be added into the value of *score*.

The two main types of variables are *numeric* and *strings*. A numeric variable holds a number, as the *points* variable does. A string variable holds a bunch of characters, like "George Washington" or "23-skidoo" or "@#$%!." You could store "10" as a string variable, but if you later told Flash to add that to "13," you would end up with "1310," not 23, because Flash doesn't know these characters are numbers. When Flash sees quotation marks in a command, it assumes it is dealing with a string, not a number.

R
E
S
U
L
T

PROCEDURE 2: SHOW THE VALUE ON THE BALLOON

1. Select frame **2** of **Layer 1** (the layer with the balloon on it).

 You are adding a points display that will appear on top of the balloon. You could add the points figure in the Balloonbutton button itself, but then you would have to worry about whether the text field would become part of the Hit area. It is easier to just add it here, right in the movie clip.

2. Get the **Text** tool A and set the font to **Impact,** the **Font height** to **26,** and the **Text (fill) color** to a dark blue.

3. Click the **Center Justify** button.

4. Drag along a line that is one grid block below the center of the balloon, starting four grid blocks to the left of center and ending four grid blocks to the right.

5. On the properties display set the **Text type** drop list to **Dynamic Text,** enter **points** in the **Var** field, and make sure the **Selectable** option button is not pushed in.

 Dynamic Text fields contain text that displays the contents of a variable. You have set it up so that it can display the value of the variable *points*. When the value stored in that variable changes, the number displayed in the text is automatically updated—that is what makes it dynamic.

RESULT

PROCEDURE 3: INCREASE THE POINT VALUE

1. On the timeline, select frame **3** of the **Actions** layer then open the actions panel. The *stop* action that you put in that frame will now be displayed.

2. Click **stop** in the script editing area, then click– (minus sign) above the editing area. The *stop* command disappears.

3. As you did in Procedure 1, double-click the **set variable** command.

4. In the parameter area, enter **points** into the **Variable** field, **points+1** into the **Value** field, and click the **Expression** option next to the Value field.

 This command will take the value of the *points* variable, add 1 to it, and store it back in the *points* variable. In other words, every time this frame is reached, the point value of the balloon increases by 1.

5. As you did in Project 11, Procedure 4, add the **goto** command to this action. Set the **Frame** parameter to **2**.

 Now every time the movie clip reaches frame 3, it increases the point value by 1, and then goes back to frame 2, after which it reaches frame 3 all over again. It alternates between these two frames, increasing the point value, until the balloon is blown up. Unlike many video games, which reward blowing things up the moment they appear, this one gives extra points to the player who waits until the last possible moment before firing.

RESULT

A DEEPER UNDERSTANDING: EXPRESSIONS

An *expression* is either a number or a calculation that results in a number. That calculation can include numbers and variables that store numbers: when the variable *points* holds the number 10, then the expression *points+1* is equal to 11.

PROCEDURE 4: STOP THE EXPLODED BALLOON

1. Select frame **4** on the **Actions** layer.

2. Using the methods from earlier in this project, put a **set variable** command in this frame, with **_parent.score** in the **Variable** field and the expression **_parent.score+points** in the **Value** field. Remember to turn on the **Expression** option at the end of the Value field.

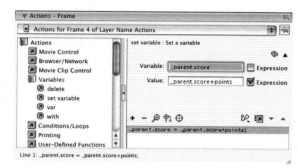

 This adds the points for blowing up the balloon into the user's score. The _par-ent. before the *score* variable name means that it is not a variable in the movie clip, but a variable in the movie clip's *parent*, the scene that holds the movie clip.

3. Insert a blank keyframe into frame **10** of the **Actions** layer.

 This extends the animation to one more frame after the explosion is done so that the remnants of the explosion don't linger on the screen.

4. As you did in Project 11, Procedure 4, insert a **stop** command into this frame.

 This keeps the movie clip from looping, automatically regenerating the balloon every time you blow it up.

5. Click **Scene 1** to return to editing the scene.

6. Create a new layer and name it **Actions.**

7. Using the techniques from Procedure 1, put a statement here that sets the **score** variable to **0.**

A DEEPER UNDERSTANDING: LEVELS

As you know, Flash lets you put symbols into your scenes, and other symbols in those symbols, and so on. Flash keeps track of this complex pile of stuff by assigning each item a *level. Level 0* is the movie's main timeline. Any symbol in that timeline, such as the Balloon movie clip, is on *Level 1.* A symbol in a Level 1 symbol (say, the Balloonbutton button) is on *Level 2,* and so on up. Each item on a lower level has a *parent,* the scene or symbol it is in; the Balloonbutton's parent is the Balloon movie clip, and the clip's parent is the main timeline.

RESULT

PROCEDURE 5: DISPLAY THE SCORE

1. Create a new layer and name it **Score display.** Select frame **1** of this layer.

2. Using the **Text** tool with the **Right/Bottom Justify** option, drag a text box just above the bottom of the stage, starting almost all the way to the left and ending almost all the way to the right of the stage.

 There is no reason not to make it this wide. This will certainly be wide enough no matter how high the score gets.

3. On the properties display, make sure the **Text type** drop menu is still set to **Dynamic Text,** and type **score** into the **Var** field.

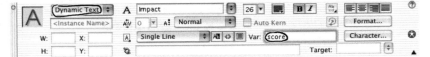

4. Just above the text box you just drew, draw another text box. Make this one only one-quarter as wide, but keep the right edge right above the right edge of the previous box.

5. Set the **Text type** drop menu to **Static Text.**

 This is the type for normal, unchanging text.

6. Type **SCORE:** into the text box.

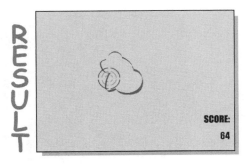

PROCEDURE 6: MORE BALLOONS!

1. Insert a new layer and set a keyframe in frame **40** of this layer.

2. Open the library and drag the **Balloon** from the library to somewhere just outside the borders of the stage.

 Reduce your magnification before you do this so you can see the borders of the stage easily.

3. Using the technique from Project 7, Procedure 7, create a motion guide for this balloon. It should start where you placed the balloon, then wander all over the stage before heading off the stage again.

4. Using the technique from Project 7, Procedure 8, put a closing keyframe for the balloon in frame **240**, then create a motion tween so that the balloon travels along the line you drew.

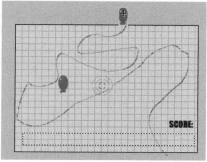

 You will have to insert a frame 240 on the guide layer so that you can see the motion guide line when you're trying to place the balloon at the end.

5. Repeating the steps on this page, add additional balloons, starting every few seconds (remember, there are 20 frames per second). Put each balloon on its own layer and give it its own motion path. Keep this up until you have balloons that are on-screen until frame 600, which may sound like a huge number of frames, but that's only 30 seconds of playing time.

 To make sure that new layers are not linked to any existing motion guide, always select the top layer on the list before inserting a new one.

6. By dragging their entries on the layer list, move the **Pointer** and **Score display** layers so they are at the top of the stack so those items are always in front of the balloons.

7. Insert a frame **600** into the **Pointer** and **Score display** layers so the crosshairs and score stay on-screen the entire time.

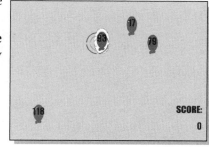

RESULT

PROCEDURE 7: CREATE A SHOOTING WINDOW

1. Select frame **1** of the **Pointer** timeline.

2. You are about to make the game a little harder so that the crosshairs can't move across the entire game field, but will be limited to a specific area. First, you have to find out how you will describe that area numerically. From the **View** menu, choose **Rulers.** Rulers appear above and to the left of your stage.

3. Decide on what rectangle you want to limit your pointer to. I've chosen that my pointer shouldn't go above the tenth pixel from the top (which is how the vertical ruler measures) nor below pixel number 390. Moving side to side, it will be stopped at pixel 100 on the left and 450 on the right.

4. Your page may be covered with motion paths, making it hard to find the lightly colored crosshairs. Click on the **Show/Hide All Layers** button (the picture of the eye) above the layer list. Red Xs appear on all the layer entries to show those layers are hidden. With everything hidden, your stage is blank!

 Remember: these layers are only hidden in the editing window. If you were to publish the movie now, everything would be visible.

5. Click the red X on the **Pointer** layer entry. The layer becomes visible.

6. Select the crosshairs then open the **Actions** panel.

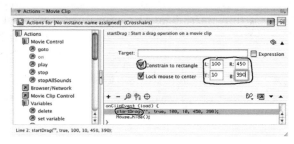

7. Click the **startDrag** command in the script editing area.

8. The dragging parameters appear below. Set the **Constrain to Rectangle** option. Set the **L** field to the left limit for the pointer, the **R** field to your right limit, and the **T** and **B** fields to your top and bottom limits.

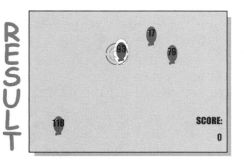

PROCEDURE 8: SET UP GUIDES

1. Turn off the grid by going to the **View** menu and choosing **Grid, Show Grid,** then going back to the **View** menu and choosing **Grid, Snap to Grid.**

2. Point to the ruler above the top of the stage and drag down. As you drag down, you'll find that you are dragging a line that runs the full length of the stage. This line is a *guide.* It won't appear in your movie; it is there to help you line things up while you're editing the movie. Think of it as a single gridline. You can see roughly how many pixels from the top of the stage the guide is by looking at the ruler on the left. Add 20 to whatever you set as the top pointer limit in Procedure 7 and put the guide there.

 Although you can drag the guide into place with any tool, only the arrow tool lets you adjust the placement of the guide after it is there.

3. Drag down another guide, placing this one at what you set as the bottom pointer limit minus 20 pixels.

You are setting up the border of the window where the player can shoot the balloons. You are creating a 20-pixel border inside that. The player will be able to move the crosshairs onto the border, but shooting the balloons won't work on the border.

4. You can drag vertical guides from the ruler on the left side. Drag one to your left pointer limit plus 20 pixels, and another to your right pointer limit minus 20 pixels.

 Are your guides hard to see? From the **View** menu, choose **Guides, Edit Guides.** A dialog box opens that lets you change the color of the guides.

5. Go to the **View** menu and choose **Guides.** If there is no check mark next to the **Snap to Guides** command, choose that command.

RESULT

PROCEDURE 9: OUTLINE THE SHOOTING WINDOW

1. Create a new layer, naming it **Window.** Place this layer below the Pointer and Score display layers but above all the other layers.

2. On this layer, drag a rectangle that covers the whole stage. This rectangle should have no stroke. Its fill should be white, with a 34% alpha setting, so it just lightens the background.

3. Pick another fill color (it doesn't matter what) and drag the rectangle that is bounded by your four guides. It will be very easy to drag the rectangle precisely because your pointer will automatically snap to the guides when you get close to them.

4. Get the **Eraser** tool [icon] (shortcut: **e**) and press the **Faucet** button [icon] in the options area of the toolbox.

5. Click on the rectangle you just dragged. The rectangle disappears, leaving a clear hole in the middle of the white rectangle.

The faucet option makes the eraser erase the point that you click on and all connected areas that are of the same color as that point.

6. Click the **Arrow** tool [icon] on the white rectangle to select it, then go to the **Insert** menu and choose **Convert to Symbol.** Make this a button symbol.

This protects the balloons while they are on the 20-pixel border. When a user clicks a point where there are buttons on more than one layer, Flash assumes the click was on the button on the highest layer. So if the user clicks while pointing to this white area, Flash detects a click on the white area, not on any balloon button behind the white area.

7. Click the **Show/Hide All Layers** button twice to reveal all the layers.

8. Save the file (keeping the name **Balloon**) and test your game! It feels like a real game now, doesn't it?

PROJECT 13
ULTIMATE BALLOON BA-BOOM! GAME

CONCEPTS COVERED

❑ Multiple layers on a guide
❑ Invisible buttons
❑ Expanding fills

REQUIREMENTS

❑ The Super Balloon Ba-boom game you made in Project 12

RESULT

❑ An enhanced game with opening and closing screens and more

PROCEDURES

1. Create a title screen
2. Create a string of balloons
3. Create a giant, invisible button
4. Copy the score
5. Game over
6. Finish the closing screen
7. One more thing . . .
8. Make it a program

PROCEDURE 1: CREATE A TITLE SCREEN

1. Open up the Balloon game file you saved in Project 12.
2. Using the same steps in Project 5, Procedure 1, add a new scene named **Title** at the beginning of your movie.
3. If you want a different colored background for the title screen, place a rectangle of that color over the entire stage.
4. Add a name for your game in **96** point type. Choose whatever name you want and use a simple font.
5. As you did in Project 10, Procedure 1, convert the text into a shape and fill it with the gradient of your choice.
6. With the text shape selected go to the **Modify** menu and choose **Shape, Expand Fill.** On the dialog box that appears, set **Distance** to **8 px** then click **OK.** Your letters expand, giving them an overinflated, balloon-like appearance.

 The best distance setting really depends on the font. Some fonts will look better with a higher value, whereas others run into problems that make the letters unreadable. Use the undo command and retry this step with different values to see what looks best with your font.

PROCEDURE 2: CREATE A STRING OF BALLOONS

1. Using the technique from Project 12, Procedure 6, add a new layer with a balloon moving across the stage. But this time use the symbol **Balloonbutton** instead of the symbol Balloon, because the Balloonbutton symbol doesn't have the score on it. Give it a motion guide that starts the symbol on the right side in frame 1 and moves it across the stage in a big, looping path, exiting on the left side of the stage at frame 250.

2. As you did in Project 4, Procedure 4, copy the frames of the layer with the balloon, and paste those frames into a new layer starting at frame 21. Make sure this new layer is between the original balloon layer and the guide for that layer.

 When you place a layer between an existing layer and its motion guide, Flash knows that you want to use that guide for this layer as well. This way, the second balloon follows the same path as the first one, just starting a second later.

3. Select the first keyframe on the new layer. Click the **Arrow** tool on this layer's balloonbutton symbol to select it.

4. On the properties display set **Color** to **Tint.** Set the **Tint Amount** to **100%.** Click the **Tint Color** button and choose a bright color from the grid of colors that appears, taking careful note of where on the grid you picked the color from. The balloonbutton symbol turns that color.

5. Select the balloonbutton in the last frame on the current layer. Repeat step 4, setting the color of the balloonbutton in the final panel to the same color that you set it to in the first panel. (Otherwise, the balloon would change color as it moved.)

6. Repeat steps 2 through 5, putting different colored balloons starting in frames 41, 61, 81, and 101. Now you have a series of balloons moving across the screen!

 You don't have to keep copying the frames. They'll be ready to paste until you copy something else.

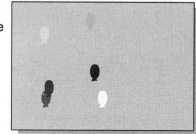

RESULT

PROCEDURE 3: CREATE A GIANT, INVISIBLE BUTTON

1. Select frame **400** on **Layer 1** and insert a frame there so that the title is visible for the entire scene.

2. In your choice of color and font and font height, add the line **Click to begin.**

3. Create a new layer named **Actions** and add a **goto** action in frame 400 of that layer, like the one you added in Project 12, Procedure 3. Use this command to go back to frame 1 so that the opening animation keeps looping.

4. Create a new layer at the very top of the layer list named **Invisible.**

5. Use the **Color Mixer** panel to set the **Fill color** to any solid color, with **Alpha** set to **0%.**

 With the alpha set to 0%, this "color" isn't translucent; it is completely transparent. But just because something is invisible doesn't mean it isn't there. (Why, just ask my invisible pal Jo-jo! Of course, you'll have to forgive him if he doesn't answer; he does have a touch of laryngitis.) Flash keeps track of where this color is on the image.

6. Get the **Rectangle** tool ⬜ , set the **Stroke Color** 🖊■ to **No Color** ⬚ , and drag a rectangle that covers the entire stage. Flash knows there is a rectangle there, even if it is perfectly clear. It is as though you put a sheet of glass over the image.

7. Get the **Arrow** �敁 tool and click anywhere on the stage. The rectangle becomes selected and Flash makes it visible so you can see it is there.

8. Go to the **Insert** menu and choose **Convert to Symbol.** Make this a button symbol.

 Because you're making this whole rectangle a button symbol, it won't matter *where* the game player clicks. A click anywhere in the game area will be seen as clicking the button.

9. Using the method from Project 5, Procedure 4, set this button to go to **Scene 1.**

PROCEDURE 4: COPY THE SCORE

1. Switch to editing Scene 1 by clicking on the **Edit Scene** button over the right of the stage and choosing **Scene 1.**

 You can also pick which scene to view by going to the **View** menu and choosing **Goto** then selecting the scene from the submenu. This submenu also has commands to take you to the first, last, next, or previous scene.

2. With the Text tool, click on the score area (not the word *Score,* but the place where the score actually appears). Then get the **Arrow** tool . The text box becomes selected.

 Selecting this box would otherwise be tough because nothing in it is visible in the editing window.

3. From the **Edit** menu, choose **Copy.**

4. From the **Insert** menu, choose **Scene** to create a new scene.

5. From the **Edit** menu, choose **Paste in Place.** A copy of the text box is placed in the new scene already selected.

6. Insert a keyframe into frame **20.**

7. Get the **Free Transform** tool and choose the **Scale** option . Sizing handles appear around the text box.

8. Drag the centermost sizing handle on the top edge up to the top of the stage.

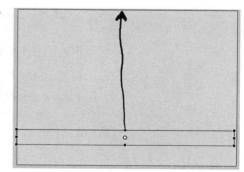

9. Select to frame **1,** then go to the **Insert** menu and choose **Create Motion Tween.**

 This tween makes the score grow smoothly to fill much of the screen.

1243 RESULT

PROCEDURE 5: GAME OVER

1. Insert a new layer and insert a keyframe into frame **20** of this layer.

2. Drag a text box *below* the stage.

 You may have to place this a fair bit below the stage so Flash doesn't think you are selecting the score area. You can drag it up after you type the text.

3. On the **Text** menu, choose **Align, Align Center.**

4. Set the fill color to black, with **Alpha** set to **50%.**

5. Type the word **GAME** into the text box.

 Make it big. On the character panel, the slider at the end of the **Font height** field won't let you pick a size greater than 96, but you can set it much higher by typing a value into the field.

6. Using the methods from Procedure 1, turn this text into a shape. Turn that shape into a graphic symbol.

 While this text shows up visibly translucent in the editing window, the player always ignores the alpha setting of text. Translucency is important for the intended effect so you need a shape rather than text.

7. Insert a keyframe into frame **60** of this layer.

8. In frame 60, drag GAME onto the upper half of the stage, then create a motion tween between frame 20 and this frame.

 Hold down **Shift** while you drag it to drag it straight up.

9. Repeat this procedure for the word OVER, starting it above the stage and moving it onto the lower half of the stage.

PROCEDURE 6: FINISH THE CLOSING SCREEN

1. Insert a frame **60** into the layer with the score so that the score stays on the screen.
2. Add a new layer and name it **Actions.**
3. Select frame 1 and open the **Actions** panel. On the panel, open up the book **Objects.** From there, go through the books **Movie, Mouse,** and **Methods,** and double-click on **Show** on the list that appears.

 This command will show the mouse pointer again, now that you don't have the crosshairs.

4. Insert a keyframe into frame **60** and put the action **Stop** into it. (That action is in the book **Actions, Movie Control.**)
5. On the layer list, click the second dot on **Layer 1,** under the picture of the lock. A picture of a lock replaces the dot, indicating that this layer is *locked,* which means you cannot alter it.

 With this layer locked, you can put text on an overlapping layer without accidentally selecting the large score display.

6. Create a new layer, put a keyframe in frame 60, and type the words **Click to try again** on this layer.
7. Go back to the **Title** scene and click anywhere on the stage. This selects the giant invisible button. From the **Edit** menu, choose **Copy** to copy the button and its actions.
8. Return to the final scene, insert a new layer at the top of the layer list, and add a keyframe in frame 20.
9. From the **Edit** menu, choose **Paste in Place** to place the invisible button. Now when the person playing clicks on this screen, the game restarts.

PROCEDURE 7: ONE MORE THING...

You should do at least one more thing to improve your game. What should you do? That is up to you. By now you have learned enough about Flash that there are a lot of things you can do. Here are a few suggestions to get your thought process started:

❏ Make the game play longer, with more balloons.

❏ Add a background behind the playfield.

❏ Add different sizes of balloons. (You can do this by scaling balloon symbol instances when you first place them in the game.)

❏ Add different colored balloons to the game. This is not as easy as it sounds. You can't use the same trick you used when making different colored balloons for the title screen; that would make the balloon and points the same color, making the points unreadable. Build new symbols for these balloons, or select a balloon and explore the *Color* drop list's *Advanced* selection.

❏ Add shields that float around in the game, protecting balloons from shots, in much the same way that the edge of the shooting window protects them.

❏ Add different sounds to play when the window edge is shot, or when a shot misses everything.

❏ Add balloons with different scoring systems (for example, balloons whose point values count down as time goes on).

❏ Put a countdown timer in the corner, showing how long the player has left.

If you think about it, you'll probably come up with a few other ways to improve this game. Although there are certainly improvements that you don't know enough about to implement yet, you can do a lot with the simple tools you have learned. And if you need more complex tools, Flash's help system has a lot of information, although much of it is designed for people with programming experience.

PROCEDURE 8: MAKE IT A PROGRAM

1. Save your file!
2. From the **File** menu, choose **Publish Settings.**
3. To make a program for a Windows PC, set the **Windows Projector** option. For a Mac, check the **Macintosh Projector** option. (If you check both, you generate both programs at once!).
4. Click **Publish.** The program is created and stored in the same folder that you saved your file in. You're a game maker! Go play your game!

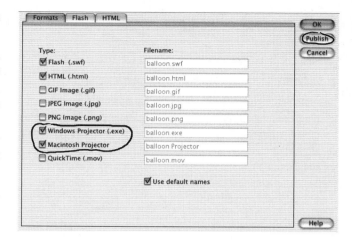

A DEEPER UNDERSTANDING: PROJECTOR PROGRAMS

Flash folks call the programs that this procedure generates *projectors*, because they include not only the movie that is being shown, but all the equipment needed to show the movie. If you send someone a projector movie, you don't have to worry about whether that person has a Flash player installed on his or her computer, and if the Flash player is current. (This balloon game requires at least version 5 of the Flash player, for example, but many people are still using version 4.) And Flash movies often play more smoothly in the projector than playing them through the Web browser.

Projectors do have their downsides, however. You have to know whether the person you're giving the game to has Windows or Macintosh. If the person doesn't have either of those, then he or she can't use a projector; in contrast, WebTV or Linux users can view Flash movies published in the usual manner. The standard movie is much more compact; the balloon game projector file is about 50 times as large as the standard movie file. And if you're distributing files on-line, it's certainly easier for someone to simply view a movie in his or her browser than it is to download a projector and then find and run the downloaded file.

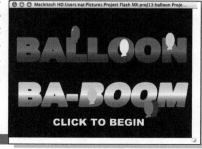

RESULT

[DONE !]

done !

CONCEPTS COVERED

- ❏ Inputting text
- ❏ Embedding fonts
- ❏ Rounded rectangles
- ❏ Turning lines into fills
- ❏ The info panel
- ❏ Moving with cursor keys

REQUIREMENTS

- ❏ None

RESULT

❏ Previously, license plate making was an art reserved for the incarcerated, but not any more! Now visitors to your Web site will be able to design their own plates.

PROCEDURES

1. Type in here
2. Make it UPPER CASE
3. Display the text
4. Make a rounded rectangle
5. How wide are the characters?
6. Resize the rectangle
7. Raise the text
8. Test it thoughtfully

PROCEDURE 1: TYPE IN HERE

1. Start a new movie, **500** pixels wide and just **100** pixels high.

2. Go to the **View** menu and choose **Rulers** to turn on the rulers.

3. Get the **Text** tool A and set the **Font** to **_typewriter** (which will be either near the top or at the very bottom of the font list) and the **Font size** to **10.**

4. Drag a text box into the lower-right corner of your image and type **0123456789** into it. By dragging the sizing handle at the corner of the box, resize the text box so that it just fits those characters. Then drag across the characters **0123456789** to select them, and press the **Delete** key to remove them.

> The reason you put those characters in there was to make the text box just the right size to hold exactly 10 characters. Although many fonts use characters of varying widths, every character in the _typewriter font takes up the same width, so this measurement works.

5. Set the **Text type** drop list to **Input Text,** making this a text field that the user can type into. In the **Var** field, type **Entry** so that whatever the user types in gets stored in a variable named Entry. Press in the **Show Border Around Text** option, so that the text field will have a visible border around it in the final movie. Set **Maximum Characters** to **10** so that the user can't type more than 10 characters into the field.

6. Use the **Arrow** tool to reposition the text box so that it is close to the lower edge and the right edge without touching them.

A DEEPER UNDERSTANDING: SYSTEM FONTS

The font _typewriter is one of three Flash *system fonts*, which means that Flash doesn't try to store the font. Instead, the Flash player finds an appropriate font on whatever system it runs on. This saves file space. Flash doesn't try to smooth system fonts the way it smooths other fonts. This means system fonts don't look good when they're big, but they're more readable than nonsystem fonts at small sizes such as the one you use here.

RESULT

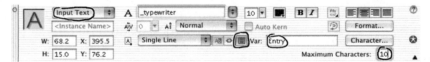

PROCEDURE 2: MAKE IT UPPER CASE

1. Rename the current layer **In Box** and insert a frame 2 into the layer.

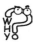 Even in a project that has no moving pieces, it is often handy to have more than one frame. If you have just one, the actions in that frame only get run through once. If you have two frames, the player will keep bouncing between the two frames, running the actions repeatedly. That is needed for projects like this one, where you will have variables in constant need of updating.

2. Add a new layer named **Actions.** Select the first frame of that layer then open the **Actions** panel.

3. Click on the list icon in the upper right of the panel and choose **Expert Mode** from the menu that appears.

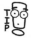 In expert mode you can type right into the script editing area. Not having to drag or double-click commands and enter parameters below makes entering some commands easier.

4. Into the script editing area, type **Display = Entry.toUppercase();** making sure to include all the punctuation and the spaces before and after the equals sign.

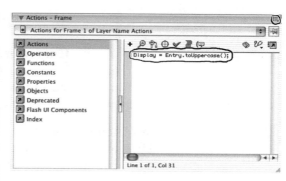

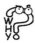 This command takes the string that the user typed into the *Entry* text box, turns all the lowercase letters into capital letters (for example, *Charlie* becomes *CHARLIE*), and stores the result in a variable called *Display.* The semicolon tells Flash that this is the end of this command.

A DEEPER UNDERSTANDING: FUNCTIONS AND PROPERTIES

In building commands, you'll often see a series of terms connected by periods. The last term is always the name of a *function* (a command that takes a variable and creates out some information based on it) or a *property* (some aspect of a variable or movie clip). Before the last term is a variable name or a *target*, one or more terms that point to a specific movie clip. In *Entry.toUppercase()*, *Entry* is a variable name and *toUppercase()* is a function that works on the variable. Later, you'll use the phrase *Plate1._width*, where *Plate1* is the name of a movie clip instance and *_width* is a property of that instance, specifically how wide it is on screen.

PROCEDURE 3: DISPLAY THE TEXT

1. Go to the **Edit** menu and choose **Deselect All,** if it isn't grayed out.

 You are about to set up the font information for the next text box, but if you do that with the old text box still selected, you'll change its font information.

2. Get the **Text** tool A and set the **Font** to **Courier New**. Set the **Font size** to **70,** make the **Text (fill) color** a medium blue, and press in the **B** (bold) button.

3. Using the same technique you used in Procedure 1, make a text field wide enough to hold 10 characters, but don't delete **0123456789** this time (it won't show up in the movie). Place the text box so that the top edge is centered on the top edge of the stage.

4. Set the **Text type** to **Dynamic Text,** choose the **Center Justify** option, clear the **Show Border Around Text** option, and type **Display** into the **Var** field.

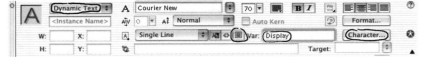

5. Click the **Character** button. On the dialog box that appears, choose the **Only** option and the **Uppercase Letters, Numerals,** and **Punctuation** options then click **Done** to set which parts of the font are embedded in your movie.

 You don't need to embed the lowercase letters, because this is only going to display an uppercase version of whatever the user types. Embedding them would just make your file bigger. If you're working on a project in which you need the entire font, just click the **Include entire font outline** button on the left.

..

A DEEPER UNDERSTANDING: EMBEDDING FONTS

Don't assume everyone has all the fonts on their computer that you have on yours. By *embedding* the font (making the font definition part of the movie), you ensure that Flash players will show the right letter shapes on any system. You don't need to do this for static text (Flash automatically embeds the necessary characters), but it can make a real difference for dynamic and input text.

```
TEST IT!
     Test it!
```

PROCEDURE 4: MAKE A ROUNDED RECTANGLE

1. Deselect everything.
2. Create a new layer, name it **Background,** and drag it to the bottom of the list.
3. Set the **Fill Color** to light blue and the **Stroke Color** to dark blue.
4. Get the **Rectangle** tool and click the **Round Rectangle Radius** option . A dialog box appears.

5. Set **Corner Radius** to **5** then click **OK**.
6. Set the **Stroke style** to **Solid** and **Stroke height** to **2**.
7. Drag a rectangle around the numbers **45** in the middle of the Display text box, leaving some margin above and below the numbers. Because the current layer is at the bottom of the list, the rectangle appears behind the numbers.
8. Click the **Background** entry on the layer list to select the rectangle you just drew.
9. From the **Modify** menu, choose **Shape, Convert Lines to Fills.**

> **WHY?** You'll stretch the rectangle horizontally later. Without this step, Flash would look at the line around the rectangle and make the whole line thicker, even at the top and bottom, because it thinks that a line has to be the same thickness always. With this step, you've told Flash to stop thinking of it as a line and just think of it as an area of color, so only the sides will thicken when you stretch it.

10. From the **Insert** menu, choose **Convert to Symbol.** Type **Plate** into the **Name** field and set **Behavior** to **Movie Clip,** then click **OK.**

RESULT

TRY IT

Try it

PROCEDURE 5: HOW WIDE ARE THE CHARACTERS?

1. For what comes next, you'll need to know how much space each letter or number takes up, including the space to the next number. To start, get the **Zoom** tool and drag a rectangle around **89** in the text field. This area of the stage is magnified in your display.

2. From the **Window** menu, choose **Info** to open the info panel.

3. Click the **Text** tool Ⓐ between the 8 and 9. If odd spacing had appeared between characters, this will correct it.

4. Point, (don't click!) the pointer to the leftmost point of the circle that makes the top of the **9.**

5. Look at the **X** value on the lower half of the info panel. Write that number down.

This value tells you how far the pointer is from the left edge of the stage, measured in pixels. Because you magnified the stage, it may not be an exact number of pixels.

6. Move (don't drag!) the pointer to the leftmost point of the circle that makes the top of the **8.**

7. Subtract the **X** value now on the info panel again from the one you wrote down, and round it to the nearest whole number. This is your *character spacing.*

Is math hard? Both Windows and the Macintosh come with calculator programs.

8. From the **View** menu, choose **Magnification, Show Frame.** The entire active stage becomes displayed again.

• •

A DEEPER UNDERSTANDING: INFO PANEL

The top half of the panel shows the size and location of the currently selected item. The right side of the bottom half shows the current pointer location, and the left half lists the color under the pointer.

R
E
S
U
L
T

PROCEDURE 6: RESIZE THE RECTANGLE

1. Use the technique from Project 13, Procedure 6 to lock every layer except the background.
2. Use the **Arrow** tool to select the background rectangle.
3. Type **Plate1** into the **<Instance Name>** field.

 By naming this instance, you'll be able to refer specifically to it in commands.

4. Select frame **1** of the **Actions** layer and open the **Actions** panel. If the panel is not in expert mode, set it to expert mode as you did in Procedure 2.
5. Click your cursor to the right of the line of the program that you entered before, then press **Return** or **Enter** to start a new line.
6. Type **Plate1._width = 50+(** into the field.

 You're creating a command that will set the width of the rectangle in the background. Remember, Flash sets the variable or property on the left of an equal sign to the value of the expression on the right of the equal sign.

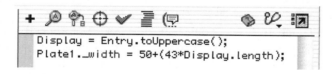

7. Type the character spacing that you calculated in Procedure 5.
8. Type ***Display.length);** to complete the command.

 The *length* function tells how many characters are in a specified variable, so *Display.length* indicates how many characters are on the license plate. The asterisk (*) is what computers use for a multiplication sign, and putting parentheses around part of the equation means *do this first*. So with this command, Flash multiplies the number of characters by the character spacing to find out how much space the text takes up, adds 50 to it, and then sets the rectangle to be that wide.

PROCEDURE 7: RAISE THE TEXT

1. License plates have raised text and you can see the light reflect differently off the edge of the letters. You can't do a great job of reproducing that effect in Flash easily, but you can at least create the suggestion of that depth. To start, unlock the layers then select the large display text box.

2. From the **Edit** menu, choose **Copy.** The text box and all its attributes are copied onto the clipboard.

3. From the **Edit** menu, choose **Paste in Place.** A second copy of the text box is put right over the first—so precisely over the first that you can't tell there are two text boxes there. It looks like just one text box.

4. Set the **Fill Color** to a darker blue. This changes the color of the type in the new copy.

5. Choose the **Free Transform** tool ⊞ .

6. Tap the **Cursor down** key (it probably has a picture of a down arrow on it), and then tap the **Cursor right** key (a picture of an arrow aimed to the right). When you hit each cursor key, the second text box moves one pixel in the indicated direction. This causes just a little bit of lighter blue to peek out around the edges.

TIP Using the cursor keys is an easy way to move items 1 pixel at a time. If you hold the cursor key down, the selected item continues to move in 1 pixel increments. If you want to make an exact movement of more than 2 or 3 pixels, however, you're better off opening the info panel and changing the **X** and **Y** fields on the upper half of the panel. Those fields show the location of the selected item, measured from the upper-left corner of the image. Change the X value to move the item side to side, and the Y value to move it up and down.

RESULT

PROCEDURE 8: TEST IT THOUGHTFULLY

1. Save your file.

2. Go to the **Control** menu and choose **Test Movie.** Your movie starts playing in a player window.

3. Type a few letters into the input field. If all is working well, uppercase versions of the letters should appear, with a rectangle stretching to surround them. If it isn't working right, don't panic—the rest of this procedure should be able to help you figure out what is wrong.

4. From the **Debug** menu, choose **List Objects.** A list of the items in your movie appears.

 ❏ Is there an entry for **Movie Clip: Frame=1 Target= "_level0.Plate1"**? If not, you either messed up turning your rectangle into a symbol or naming the instance of the symbol.

 ❏ Is there an entry that has **Variable=_level0.Entry** and ends with **Text=** followed by whatever you have typed into you entry field in quotes? If not, you likely made a mistake in entering the variable name for the small text box.

 ❏ Are there two entries for **Variable=_ level0.Display** that end with an all uppercase version of what was in the previous entry? If the word *Display* isn't right, you likely erred when entering the variable name on the properties display. If the text isn't right, then you probably made a mistake when entering the first action.

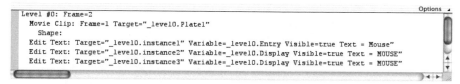

```
Level #0: Frame=2
   Movie Clip: Frame=1 Target="_level0.Plate1"
      Shape:
   Edit Text: Target="_level0.instance1" Variable=_level0.Entry Visible=true Text = Mouse"
   Edit Text: Target="_level0.instance2" Variable=_level0.Display Visible=true Text = MOUSE"
   Edit Text: Target="_level0.instance3" Variable=_level0.Display Visible=true Text = MOUSE"
```

5. If everything in the debug window looks right but you still have problems, check into the following possibilities:

 ❏ If you can't type into the small text box at all, you probably picked the wrong text type for it.

 ❏ If the rectangle is not stretching correctly, this is likely an error in the second action you entered.

 ❏ Are you all out of donuts? That's not a problem, that's a tragedy!

[DONE !]

done!

R E S U L T

PROJECT 15

CUSTOM ALARM CLOCK

18 ³⁴
9 04

CONCEPTS COVERED

- ❏ Recording sounds
- ❏ Importing sounds
- ❏ Panning sounds
- ❏ Editing sounds
- ❏ Time objects
- ❏ Conditional statements

REQUIREMENTS

- ❏ A microphone, properly connected to your computer. If you don't have a microphone, you'll have to go to:

 www.delmarlearning.com/companions/projectseries/

 and download a recording of my own screeching tones.

RESULT

- ❏ An alarm clock wakes you up with your own voice (or if you don't have a microphone, my annoying twang). Note: *Do not rely on this alarm clock!* Using a computer alarm clock can be a very bad idea, because most computers go to "sleep" if you're not actively using them and this alarm clock will stop running in sleep mode. This is meant as a Flash exercise and not as a way to save you from spending $3.99 on a real alarm clock at your local Kwality-Mart.

PROCEDURES

1. Record your voice (Macintosh)
2. Set up your microphone (Windows)
3. Record your voice (Windows)
4. Import the sound
5. Make a clock
6. Set the alarm
7. Alarming logic
8. Throw your voice
9. Edit your voice
10. Become annoying
11. Turn off the alarm
12. Test and fix

PROCEDURE 1: RECORD YOUR VOICE (MACINTOSH)

1. Look at your computer. Does it have a microphone? If not, go to www.delmarlearning.com/companions/projectseries/ and download the needed audio file from there, then skip to Procedure 4. Is the computer a Mac? If not, go to Procedure 2. Are you using OS X? Then you'll need to download the sound, unless you have your own recording program. (OS X doesn't include one.)

2. In Finder, open up your hard disk, go into your **Applications** folder then into the **Apple Extras** subfolder, and start the program **SimpleSound.**

3. From the **Sound** menu, choose **Speech Quality.**

 Speech quality sound takes up much less disk space than *music quality* or *CD quality* sound and is good enough for recording this. (Unless your computer is in a music studio with a studio-quality microphone, all CD quality will get you is very precise reproduction of the static and background noise that your microphone puts out.)

4. Go to the **File** menu and choose **New.** A set of recording controls opens up.

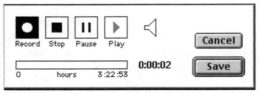

5. Click the **Record** button.

6. Say **It's time to wake up now!** into the microphone.

7. Click **Stop.**

8. Click **Save** and use the file navigator that appears to find a convenient directory, enter **WakeUp** into the **Save file as** field, and click **Save.**

9. Go to the **File** menu and choose **Quit.**

10. Skip to Procedure 4.

PROCEDURE 2: SET UP YOUR MICROPHONE (WINDOWS)

1. If your computer doesn't have a microphone, go to:

 www.delmarlearning.com/companions/projectseries/

 for instructions on downloading the sound file. Once you have downloaded the file, skip to Procedure 4.

2. Click the Windows **Start** button and choose **Program** or **All Programs, Accessories, Entertainment, Volume Control.** A volume control window opens.

 If you can't find this command, look at the right end of your Windows task bar. If you see a little picture of a slider there, double-click it and the volume control window should open.

3. From the **Options** menu, choose **Properties.** A dialog box appears.

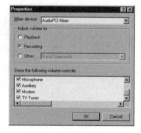

4. Select the **Recording** option.
5. Put a check in every check box in the **Show the following volume controls** area.
6. A row of sliders is displayed, listing settings for different audio input devices. Each slider has a check box marked **Select** under it. Make sure the **Select** option for the **Microphone** slider is checked and that all the other sliders are cleared.
7. Drag the **Microphone** slider all the way to the top.
8. From the **Options** menu, choose **Exit.**

PROCEDURE 3: RECORD YOUR VOICE (WINDOWS)

1. Click the Windows **Start** button and choose **Program** or **All Programs, Accessories, Entertainment, Sound Recorder** (if you don't have an Entertainment submenu, try **Multimedia**). A recording program window opens.

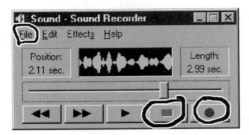

2. Click the **Record** button (the one with the circle on it).
3. Say **It's time to wake up now!** into the microphone.
4. Click the **Stop** button (the one with the square on it).
5. From the **File** menu, choose **Properties.** A dialog box appears.
6. Click the **Convert Now** button. Another dialog box appears.
7. From the **Name** field, choose **Radio Quality.** Click **OK** on this dialog box to close it then click **OK** on the properties dialog box to close that as well.

 Radio quality sound takes up much less disk space than *CD quality* sound and is certainly good enough for recording this. (Unless your computer is in a music studio with a studio-quality microphone, all CD quality will get you is more precise reproduction of the static and background noise that your microphone puts out.)

8. Go to the **File** menu, choose **Save,** and use the file navigator that appears to find a convenient directory. Enter **WakeUp** into the **File name** field and click **Save.**
9. From the **File** menu, choose **Exit.**

Procedure 4: Import the sound

1. Start Flash.

2. Create a new movie with a **Frame Rate** of **4** fps, a **Width** of **200** pixels, a **Height** of **100** pixels, and the **Background Color** set to black.

 You don't need a high frame rate in this movie because nothing will be moving. A movie with a low frame rate requires less computer processing power than one with a higher rate.

3. Using the techniques from Project 6, Procedure 1, import the sound file into your project.

If you're using a Macintosh, set the **Show** drop list to **All Files.** Don't be tempted to set it to *All Formats* or *All Sound Formats* because these will actually ignore some sound files.

..

A DEEPER UNDERSTANDING: AUDIO FILE FORMATS

One way that Flash for Windows differs from Flash for the Mac is what audio file formats it understands. People recording raw audio on Windows machines usually work with a format called *wav* (short for *wave*), so Flash for Windows can read wav files. However, unless you have the Quicktime program installed on your system it can't read *AIFF (Audio Interchange File Format)* files, which are the standard on the Macintosh, nor can the Mac version of Flash read wav files. It's a modern tower of Babel!

Don't worry, though; when Flash saves the movies, the audio is re-encoded in a format that can be read by Flash players on any platform.

RESULT

PROCEDURE 5: MAKE A CLOCK

1. Change the name of the first layer to **Actions.**
2. Select the first frame, open the **Actions** panel, go into **Expert Mode,** and enter the following:

 Now = new Date();
 Hours = Now.getHours();
 Minutes = Now.getMinutes();

 The first line creates a new *object* called *Now*. An object is like a complex variable with a built-in format. In this case, you are making one with the *Date* format, a format that includes not only information on what date it is, but what time it is down to the millisecond! This new object automatically has the current time stored in it. The other two lines are separating out bits of that information, creating a variable called *Hour* that contains the current hour of the day (from 1 to 24, because there is no A.M./P.M. tracking) and one called *Minute* with the current minute (from 0 to 59, of course).

3. Create a new layer named **Clock.**
4. Using the technique from Project 14, Procedure 3, create a two-character-wide dynamic text box that displays the contents of the **Hours** variable on the left side of the stage. Pick whatever font, color, and size you feel like, making sure that it doesn't take up more than two-thirds of the height of the frame.
5. Create another dynamic text box next to the first one, displaying the **Minutes** variable.

 You can make it a different size, a different font, or you can add a static text box with a colon between the two dynamic text boxes. It is yours to design!

R
E
S
U
L
T

18 11

PROCEDURE 6: SET THE ALARM

1. Create a new layer called **Alarm settings.**
2. Using the technique from Project 14, Procedure 1, create a small input text box (big enough for two characters with some extra space) below the dynamic text boxes. Use the **_type-writer** font, with a font height of **12** and black for the color. Into the **Var** field, type **AlarmHours.** Set **Maximum Characters** to **2** and select the **Show Border Around Text** option.

 The person using the alarm clock will type the hour for the alarm to go off in this field.

3. Click the **Arrow** tool. The text box becomes selected.
4. From the **Edit** menu, choose **Copy.** The text box is copied onto the clipboard.
5. From the **Edit** menu, choose **Paste in Place.** A copy of the input text box is placed right over the old one.
6. Hold down the **Cursor right** key. The copied text box moves right. When there is some visible space between it and the original text box, release the key.
7. On the properties display set **Var** to **AlarmMinutes.**

 This is a field for entering the minute of the time when the alarm should go off.

PROCEDURE 7: ALARMING LOGIC

1. Insert a keyframe into frame **3** of the **Actions** layer.

2. On the **Actions** panel, click the list icon on the upper right and choose **Normal mode** from the list that appears.

3. In the left area of the panel, open the **Actions** book then go into the **Conditions/Loops** book and double-click the **if** entry.

 If is what programmers call a *conditional statement.* In other words, you are telling the computer that you want to execute a certain command only if certain conditions are met.

4. In the parameter area, type **Hours != Number(AlarmHours)** into the **Condition** field.

 The *Hours* variable holds the hour of the current time. The *!=* part is computerese for "is not equal to." The *Number(AlarmHours)* operator translates the string typed into the AlarmHours field into a number. So in English the command now says *if the current hour is not equal to the hour the user typed in . . .*

5. Double-click the **goto** command in the **Movie Control** book. This adds the command *gotoAndPlay(1);* between the {curly brackets} that follow the if command. Whatever is in those curly brackets is what Flash will do if the conditions are met. So now the command is *if the current hour is not equal to the hour the user typed in then go to frame 1.*

6. Double-click the **else if** command in the **Conditions/Loops** book. This sets up a second condition to be tested only if the first one isn't true.

7. In the parameter area, type **Minutes != Number(AlarmMinutes)** into the **Condition** field.

8. Double-click the **goto** command in the **Movie Control** book. Now Flash will head back to frame 1 whenever the hour or the minutes don't match the time for the alarm to go off. The only way to reach frame 4 now is when it is time for the alarm to go off!

R
E
S
U
L
T

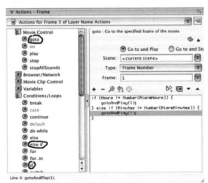

PROCEDURE 8: THROW YOUR VOICE

1. Create a new layer, name it **Noise,** and insert a keyframe into frame **4** of this layer.
2. On the properties display open the **Sound** drop list and choose the **WakeUp** sound.

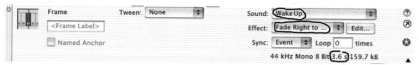

3. Open the **Effect** drop list and choose **Fade Right to Left.**

This will make your recording start in the right speaker and move to the left speaker, as if you were moving between the speakers while you said your line.

4. At the bottom of the properties display is a bunch of numeric details about your recording. Find the one that ends in **s** (such as 3.6 s)—that is the number of seconds that your recording takes. Write this number down.
5. Multiply the number of seconds by 4 (the number of frames per second) to figure out how many frames the sound takes up. For example, 3.6 × 4 = 14.4, so 15 frames later the sound is over. Because the sound starts in frame 4, it is over by frame 19.
6. Add another four frames to put a gap between sounds (in my example, I'm up to frame 23 now).
7. Select that frame number on the **Noise** layer and insert a keyframe.
8. Open the **Sound** droplist and choose the **WakeUp** sound to play it again starting in this frame.

RESULT

18 34
9 04

PROCEDURE 9: EDIT YOUR VOICE

1. Click the **Edit** button on the properties display. A dialog box opens, displaying two wavy shapes (actually, one shape displayed twice). That is your sound wave! The top one is the sound for your left speaker, and the bottom one is for your right. This would make a lot more sense if you turned your monitor sideways.

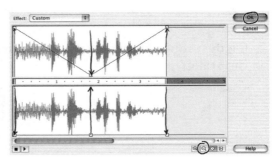

2. Click the **Zoom Out** button (the magnifying glass with the minus sign) repeatedly until your entire wave is on screen, with a little empty area to the right.

3. There is a little box that looks like sizing handle in the upper-left corner of each wave display. Take the one from the lower display and drag it straight down to the bottom of the wave. As you drag, a horizontal line coming out from it moves down as well. This line represents the volume of the sound in this speaker—you have just silenced the right speaker.

4. Point to the volume line, picking a point about halfway across the wave, and drag up to the top of the wave. A new box appears on the line where you drag it. Now the line runs from the lower corner where you placed the first block to the upper center where you placed the second block, which means the sound in the right speaker will get continually louder during the first half of the recording.

5. Point to the volume line at the right end of the wave and drag it straight down. Another box appears. Now the sound will grow quieter as the second half of the sound plays.

6. Whenever you placed a new box on the volume line for the lower wave, a new box appeared on the line for the upper wave. Drag the center box for the upper wave straight down. The left speaker will now be loud at the beginning and at the end, but quieter in the middle. It will sound as if you're moving from left to right and back again!

7. Click **OK** to close the dialog box.

RESULT

18 34

9 | 04

PROCEDURE 10: BECOME ANNOYING

1. Insert another new keyframe in the **Noise** layer, extending the layer by as many frames as you did in Procedure 8.

2. On the sound panel, set **Sound** to **WakeUp** again and click **Edit**. The sound editing window opens.

3. Click the zoom out button until the whole wave is visible.

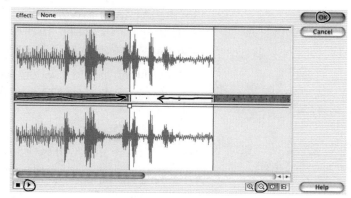

4. Look at the wave shape. You probably see about half a dozen spots where the wave gets very big. Those are where you are saying words. On the ruler line between the two wave pictures, there are little posts at the beginning and at the end of the wave. Drag the left post toward the right, and a vertical line drags along with it. Place that line between the third and fourth big spots on your wave.

 The ruler is marked in either seconds or frames. You can switch between those two ruler markings by clicking on one of the buttons in the lower right—the button with the picture of the clock sets it to seconds, while the one with the filmstrip sets it to frames.

5. Click the **Play** button in the lower-left corner (it has a picture of a triangle on it). You should now hear "wake up now." If the first word isn't "wake," move the post and try again until you find it.

6. Move the second post to between the next-to-last and the last big spot. As you do, the end of the wave disappears. Test this and you should hear "wake up." If not, readjust the post and try again.

7. Click **OK** to close the dialog box.

8. On the sound panel, set the **Loops** value to 9999.

 You want this sound to repeat until someone turns off the alarm.

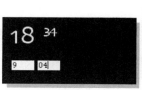

PROCEDURE 11: TURN OFF THE ALARM

1. Select frame **1** of the **Actions** layer, then go to the **Edit** menu and choose **Copy Frames.**

2. On the **Actions** layer, select the same frame number as the keyframe you created in Procedure 10, then go to the **Edit** menu and choose **Paste Frames.**

 This will keep the clock variables updated so that the clock will continue displaying the right time even if the alarm is allowed to run for more than a minute.

3. Insert a keyframe four frames later on the same layer, and insert an action there that will go back to the previous keyframe.

 The time will be updated once a second so you won't miss when the new minute starts.

4. For the same frame number as the keyframe you just added, insert frames for the **Clock** and **Alarm settings** layers so that the clock and settings stay visible the entire time.

5. Create a new layer named **Switch** at the top of the layer list and insert a keyframe in frame 4 of this layer.

 You don't need a switch to turn off the alarm until the alarm is going. Given the style of switch you are making, if you put it in frame 1 the user wouldn't be able to get to the setting fields.

6. As you did in Project 13, Procedure 3, create an invisible button that covers the entire stage. For its actions, open up the actions panel in normal mode, open the **Actions, Movie Control** book, and double-click **Stop All Sounds** followed by **goto.**

 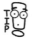 Before dragging the rectangle, use the technique from Project 14, Procedure 4 to reset the corner radius to **0**.

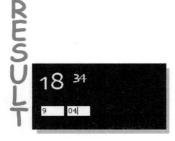

PROCEDURE 12: TEST AND FIX

1. Save your file! (In fact, you should learn to save your files several steps along the way so if something goes wrong you have a recent OK-version to revert to.)

2. From the **Control** menu, choose **Test Movie.** Your project opens up.

3. If all is working well, the current time will be displayed. Enter the current hour into the first input field, the current minute into the second, and the alarm goes off. Click on the clock and the alarm resets.

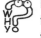 Did the alarm go off again immediately? That's because the setting and the current time still match. Try to think of a way to avoid that, other than waiting a full minute before turning off the alarm.

4. Did a window named *Output* open up? Flash is telling you that you messed up one of the actions, that you wrote something it can't understand. The window will give you details on where the problem action is and why Flash considered it confusing. Close the player window, select the frame with the problem action, and open the **Actions** panel. Carefully study not only the line that Flash said confused it, but also the lines before and after that line. Mistyped commands, missing parentheses, typing a (when you meant a {, and similar errors are common.

```
                                                    Options ▲
Scene=Scene 1, Layer=Actions, Frame=3: Line 4: '(' expected
        } else if Minutes != Number(AlarmMinutes)) {
```

5. If the output window doesn't open but your clock still isn't working, go to the **Debug** menu and choose **List Variables.** A list of all the active variables in your project appears, including the name of the level or instance name that the variable is in, and the current value of the variable. This can help in your detective work to find the problem.

```
                                            Options ▲
Level #0:
Variable _level0.$version = "MAC 6,0,21,0"
Variable _level0.Hours = 16
Variable _level0.Minutes = 17
Variable _level0.Now = [object #1, class 'Date']
Variable _level0.AlarmHours = "12"
Variable _level0.AlarmMinutes = "34"
```

RESULT

PROJECT 16
HEAD-BOPPIN' GUY

CONCEPTS COVERED

❏ Brush modes
❏ Custom strokes
❏ Color picker
❏ Easing motions
❏ Auto rotate
❏ Smoothing

REQUIREMENTS

❏ None

RESULT

❏ An animation of a guy bopping his head

PROCEDURES

1. Create a hair texture
2. Pick a skin color
3. Draw a head
4. Two eyes
5. A mouth and headphones
6. Bop the head
7. Shape the shirt
8. Paint the shirt

PROCEDURE 1: CREATE A HAIR TEXTURE

1. Start a new file, with the **Width** and **Height** both set to **400** pixels, **Frame Rate** set to **12** fps, and the **Background Color** set to pink.
2. Get the **Oval** tool 🔘 and set the **Stroke Color** to black.
3. On the properties display click **Custom**. A dialog box opens up.

4. Set **Thickness** to **8** pts, **Type** to **Stipple, Dot Size** to **Medium, Dot Variations** to **Varied Sizes,** and **Density** to **Very Dense.** A preview of what your lines will look like appears in the upper left. Click **OK.**

Although you'll be working with solid lines most of the time, the stroke panel gives you access to a range of dashed, rough, and irregular lines. When you choose a custom line, you get to select from a range of general line styles, each of which has its own settings. For example, when working with a dashed line you can set how long the dashes are and how long the spaces between the dashes are.

PROCEDURE 2: PICK A SKIN COLOR

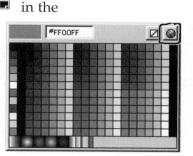

1. Click on the color portion of the **Fill Color** button in the toolbox. When the swatches of color open up, click the circle button in the upper right-hand corner. The dialog box that appears is the *color picker,* which lets you select colors more precisely than you can with the mixer panel or the swatches panel.

2. If you're using a Macintosh, on the left is a scrollable list of different methods of picking color. Click on **HSV,** and the tools to pick your color by its *hue, saturation,* and *value* appear on the right. Drag the slider below the color wheel to the point that is as dark as you want the skin tone to be. On the color wheel, pick the point that matches the color you want. The color you've selected appears in the New field. When you have the color you want, click **OK.**

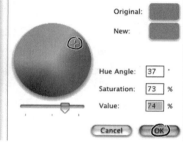

If you think of the color wheel as a clock face, most of the natural skin colors are around 2 o'clock.

3. If you're using Windows, set **Hue** to **30** and **Sat** (short for *saturation,* the richness of the color) to **120,** to work in the general range of skin tones. Use the slider on the right to adjust the brightness of the skin tone (which sets the value marked *lum,* short for *luminance* and is the same as the Macintosh's *value*). Then drag the crosshairs in the large, multicolored box to fine-tune the color. When you have the color you want, click **OK.**

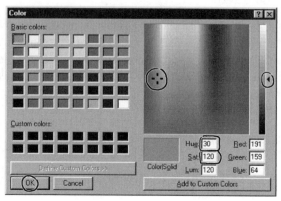

RESULT

PROCEDURE 3 DRAW A HEAD

1. From the **Insert** menu, choose **New Symbol.** Make this a graphic symbol named **Head.**

2. Turn on the rulers. Notice that the 0 point of the rulers is not in the upper-left corner. When you are editing a symbol, the 0 point is on the crosshairs at the center of the symbol, and the ruler counts in both directions from there.

3. With the **Oval** tool drag an oval that goes from about the **50**-pixel point to the left of the center to the **50**-pixel point to the right of the center, and from about **150** pixels above to about **25** pixels below the center. The oval appears with a big, hairy outline around it.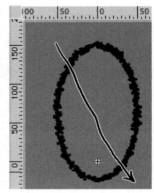

4. Using the arrow tool, drag a rectangle that covers the bottom half of the oval. That bottom half becomes selected.

> When you selected the bottom half, the outline stroke in that area became solid rather than ragged. Flash visually transforms irregular strokes like this one when you're doing certain operations, but it is only temporary. If you were to deselect this area, the line would become ragged again.

5. While holding down the **shift** key, click inside the selected portion of the oval. The selection becomes deselected, leaving only the outline stroke selected.

> When you're selecting things, the shift key serves two purposes. Hold down the shift and click on unselected items, and they become selected in addition to, rather than instead of, the existing selection. Click it on one of a number of selected items, and that item becomes unselected while the other items remain selected.

6. Press the **Delete** key. The beard part of the outline disappears, leaving only the hair on top.

PROCEDURE 4: TWO EYES

1. Get the **Oval** tool 	☐ and use it to draw a big, white, strokeless eyeball on the left part of the face. Around 25 pixels in each dimension should be good, although feel free to stretch it or shrink it in either dimension if your muse inspires you.

2. Select the **Brush** tool 	☐ and set the **Fill Color** ☐ to whatever color you want the eyes to be. In the Options area, choose a circular brush with the biggest brush size.

3. Click on the **Brush Mode** button, which is in the upper left of the Options area. Choose **Paint Inside** from the list that appears.

4. Go to the top of the eye and click the brush in a spot where most *but not all* of the brush is over the eye so that it looks as if the guy has rolled his eyes up.

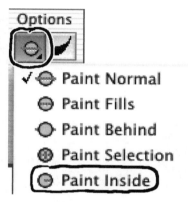

Notice that the iris (the colored part of the eye) doesn't go beyond the eyeball, despite the fact that when you clicked, part of the brush was above the eyeball. This is because you have the brush mode set to *paint inside*, which means the brush will only paint over the item that you first started dragging on. Because the center of the brush started on the white area, it wouldn't paint outside the white area.

5. With the arrow tool, click on the white of the eye then hold down the **Shift** key and click on the colored part. They both become selected.

6. While holding down the Windows **Alt** key or the Macintosh **option** key, drag the eye to the right. A second eye appears.

RESULT

PROCEDURE 5: A MOUTH AND HEADPHONES

1. Use the **Brush** tool to paint a smile on the face.

 🔧 Use a fairly thin black line. This is a fairly cartoony image, and that line should be enough to suggest where the lips meet.

2. Click the **Arrow** tool 🔺 on the mouth to select it.

3. In the Options area, click the **Smooth** button 🔘 and the line becomes smoother. Click it again and it becomes smoother still. Keep clicking it until the line stops changing.

 🔧 When you smooth a shape, not only does it look neater, it simplifies Flash's definition of the shape. This makes your files smaller and helps keep your animation from slowing down.

4. Deselect the smile.

5. Set up the **Brush** tool with a big round blue brush.

6. Click the **Brush Mode** button in the Options area and choose **Paint Behind** from the list that appears.

 ❓ This option paints only on blank areas of the layer. That way, you can run your brush near or over the edge of something without worrying about painting over what's already there.

7. Drag the brush down a short stroke along each side of the head. These are his head-phones!

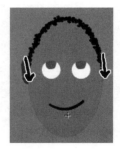

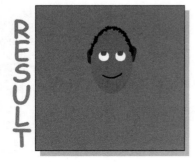

PROCEDURE 6: BOP THE HEAD

1. From the **Insert** menu, choose **New Symbol.** Make this a graphic symbol named **Guy.**

2. Go to the **Window** menu and choose **Library** to open the library.

3. Drag the **Head** symbol from the library into this new symbol, placing it so the reference crosshairs in the head symbol are over the crosshairs in the center of the stage.

4. Get the **Free Transform** tool with the **Rotate** option and tilt the head about 10 degrees to the left.

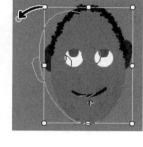

Notice that when you tilt the head, it rotates not around its center, but around its reference point. That is how all symbols rotate. In fact, this is why I had you draw the head mostly above the crosshairs, so that when his head rotates it looks more like a head bobbing than a face spinning.

5. Insert a keyframe into frame **24** then another keyframe into frame **13.**

6. In frame 13, rotate the head about 45 degrees to the right.

7. Reclick frame **13** on the timeline to display the frame properties. Set **Tween** to **Motion, Rotate** to **Auto,** and **Ease** to **–100.**

The rotate setting creates a simple motion tween with the head tilting from position to position. *Ease* sets the acceleration of the tween motioned. With a zero setting, the motion stays at the same speed the whole time. With a positive value, the motion starts fast but slows as it nears the last frame. A negative value does the opposite.

8. Select frame 1 and set **Tween** to **Motion, Rotate** to **Auto,** and **Ease** to *positive* **100.**

9. To see the motion, go to the **Control** menu and choose **Loop Playback** so the motion keeps repeating. Then go to the same menu and choose **Play.** When done, go to that menu and choose **Stop.**

RESULT

PROCEDURE 7: SHAPE THE SHIRT

1. Create a new layer named **Shirt** on the top of the layer stack.

2. Get the **Pen** tool (shortcut: **p**) and set the stroke color to black, the fill color to a dark nonblack color, and the **Stroke style** to **hairline.**

TIP: This style gives you the thinnest possible line, no matter how the object is resized.

3. Draw the shirt. To draw the shirt with the pen tool, you don't have to trace its entire outline. Instead, think of the outline as a series of straight lines. For each straight line, point to where you want the center of that line, then drag in the direction you want the line to run. Do this for each line you want for the outline of the shirt, going around the edge of the shirt. The neck of the shirt should overlap the guy's chin, and the bottom of the sleeves and the torso should be below the 200-pixel mark on the ruler.

TIP: The longer your drags are, the sharper the corners will be where the two lines meet. You can make a round shoulder by placing the sleeve and top-of-the-shoulder points with short drags. Similarly, you can get fairly sharp underarms by using long drags for both the inner sleeve and the torso.

4. Once you have dragged the last line into place, click back on the first point you placed. This shows Flash that you're done with the shape and it fills in the inside.

TIP: If you are not satisfied with the shape, get the **Subselect** tool (shortcut: **a**) and click on the outline to see the series of points that are there. Don't be surprised if there are more points than you put there, as Flash sometimes fills some in. You can drag these points. You can also click on a point and see the handles of this point, which you can then drag to change how the line flows through the point.

RESULT

PROCEDURE 8: PAINT THE SHIRT

1. Click the **Arrow** tool on the interior of the shirt to select it.

2. Get the **Brush** tool . In the Options area, click the **Brush Mode** button and choose **Paint Selection.**

 With this selected, the brush will only work on the selection. The rest of the image is protected. It has a necessary second benefit: with this option selected, you can change the fill color and Flash *won't* automatically change the color of the selected area.

3. Set the **Fill Color** to a bright color.

4. Scribble across the shirt. Don't worry about going outside the edges because although the paint will appear to go everywhere you drag, the paint that is not on the shirt disappears once you release the mouse button.

5. Repeat steps 3 and 4 several times with different bright colors. Try different brush sizes and shapes as well.

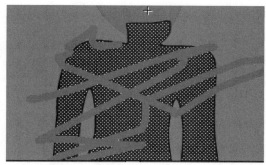

If you're drawing with a pressure sensitive tablet instead of a mouse, click the **Use Pressure** button, which is the one with the tadpole shape on it in the Options area. With this selected, the width of your paint line varies, depending on how hard you press the stylus to the tablet.

6. On the layer list, drag the **Shirt** layer to the bottom of the list. Now the neck of the shirt isn't blocking his chin.

7. Open up **Scene 1.** Open the library and drag **Guy** into the scene, then insert a frame in frame **24.**

8. Test and save your file! Now you have a garrishly dressed guy bopping his head to music that only he can hear. After the Project 17, you'll be able to listen along with him.

RESULT

PROJECT 17
MUSIC VIDEO

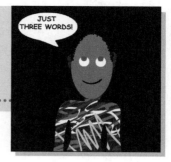

CONCEPTS COVERED

❏ Streaming sound
❏ Advanced effects
❏ Brightness effect
❏ Controller

REQUIREMENTS

❏ The file with the head-boppin' guy from Project 16, and a certain MP3 music file downloaded from the Internet. *Note: The members of the band Strange Not Dead grant you permission to use this music in Flash movies you make and distribute as long as those movies are not done for commercial purposes.*

RESULT

❏ A music video

PROCEDURES

1. Start with the music
2. Create some stripes
3. Spin the stripes
4. An opposite spin
5. Put the guy in shadows
6. A word balloon
7. The guy sings!
8. Repeat the words
9. Clean up the end

PROCEDURE 1: START WITH THE MUSIC

1. Set your Web browser to:

 www.delmarlearning.com/companions/projectseries/

 to find instructions for downloading the song "Just Three Words." Download that song.

2. Start a new file, with **Width** and **Height** both set to **400** pixels, **Frame Rate** set to **12** fps, and the **Background Color** set to pink.

3. Import the downloaded file, as you did in Project 15, Procedure 4.

4. Rename **Layer 1** as **Music** and select frame **1**.

5. On the properties display set **Sound** to the song and **Sync** to **Stream.**

6. Look at the number of seconds listed at the bottom of the properties display. Multiply that number by 12, round the result up to the next whole number, and insert a frame in that number frame. Now there's room for the whole sound to play.

A DEEPER UNDERSTANDING: STREAMING SOUND

Flash can *stream* sounds and movies over the Web, which means that the player doesn't have to wait until it gets the whole movie or sound before starting to play it. If you have a movie that runs for a minute but the sound takes 20 seconds to download, the movie can still start running immediately. While one portion of the sound is playing, the rest of it is still downloading.

When Flash plays streaming audio, it assumes that you want to keep the audio synchronized with the visual parts of your movie. As you may have seen with the balloon game, complex movie animations can slow down and run at less than their intended frame rate. If this happens while streaming audio is playing, the Flash player will simply skip over some frames of the movie, keeping the current frame showing.

RESULT

PROCEDURE 2: CREATE SOME STRIPES

1. Create a new layer named **Pattern.**
2. Turn on the rulers and the grid.
3. Use the **Zoom** tool 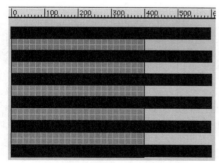 with the **Reduce** option to zoom out until the horizontal ruler displays both the 0 mark and the 600-pixel mark.
4. Set up the **Rectangle** tool to draw black, strokeless rectangles, and drag a rectangle from the upper-left corner out to the 600-pixel mark two gridlines high.
5. Using the **Arrow** tool while holding down the Windows **Alt** key or the Macintosh **Option** key, drag the rectangle down. This makes a copy of the rectangle. Place it below the first rectangle, with a two-grid space gap between them.
6. Repeat step 5, adding additional copies of the rectangle with a two-grid space gap from the previous one until you reach the bottom of the frame.
7. Select all the rectangles by clicking on the layer name on the layer list, then convert this group of rectangles into a graphic symbol named **Stripes.**

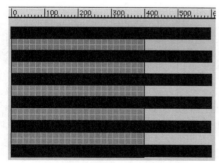

8. Drag the symbol so that its center is one grid square to the left of the center of the frame.

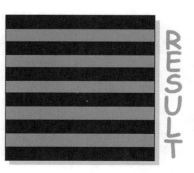

PROCEDURE 3: SPIN THE STRIPES

1. On the **Pattern** layer, insert a keyframe into the same frame number as the end of the music layer.
2. Select frame **1**.
3. On the properties display set **Tween** to **Motion, Rotate** to **CW,** and **times** to **8**.
4. Click the **Arrow** tool on the stripes symbol to select it.
5. On the properties display set **Color** to **Advanced** then click the **Settings** button that appears. A dialog box opens.

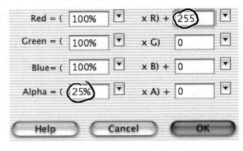

6. Set the **Red** variables so that line reads **Red = (100%xR)+255.** Set the **Alpha** variables so that line reads **Alpha = (25%xA)+0.**

These mathematical calculations set the amounts of red (R), green (G), blue (B), and alpha (A) in each pixel of the instance, based on the amount that the symbol naturally has.

7. Click **OK**.

A DEEPER UNDERSTANDING: ADVANCED EFFECTS

While the effects you have used earlier let you set the entire item to a single color or alpha value, the advanced effect can alter each color of a multicolored item by changing the color values mathematically. For example, consider a symbol with a pure green cat and a pure red monkey, and your advance effect has the line *Green=(75%xG)+20*. The 75% part means that both creatures are made three-quarters as green as they were before. This dims the green of the cat without altering the monkey. Then the *+20* part adds 20 units of green (on a scale from 0 to 255) to both creatures, so while the cat ends up less green than he started, the monkey ends up more green than she started.

RESULT

PROCEDURE 4: AN OPPOSITE SPIN

1. Create a new layer named **Pattern 2.**

2. Open the library and drag an instance of **Stripes** onto the layer, placing the center of the instance so that it is one grid square to the *right* of the center of the frame.

3. Insert a keyframe for the animation's last frame. Move the instance in the last frame down two grid squares so that the rectangles in this instance cover up the blank space between the rectangles on the previous layer.

4. Return to the first frame and set up a motion tween that has the instance rotating counterclockwise (**CCW**) 7 times.

 By rotating these line fields in opposite directions, a flexing grid effect is created. By having them rotate a different number of times, the direction the grid stretches in will seem to change. (You can see what I mean if you try setting this one to rotate 8 times and testing it, then setting it down to 7 and testing it again.)

5. Use the same sort of advanced effect that you used in Procedure 3, still setting the same alpha calculation, but setting the **Blue** value to **+255** rather than the red value.

RESULT

PROCEDURE 5: PUT THE GUY IN SHADOWS

1. Without closing the project that you are working on, open up the file with the head-boppin' guy you made in Project 16.
2. Open up the library.
3. Go to the **Window** menu and choose the project you're currently working on from the list of open projects at the bottom of the menu.
4. Create a new layer at the top of the layer list and name it **Bopper.**
5. Drag the **Guy** symbol from the open library and place it toward the center of the frame, placing it low enough that the bottom of the shirt and sleeves are below the bottom of the frame.
6. Insert a keyframe into the last frame of the **Bopper** layer.
7. Select frame **1** of this layer, then select the guy symbol on the layer.
8. Set **Color** to **Brightness** and drag the value field slider all the way down so its value is **–100%.**

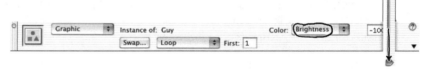

 That negative 100% drains all of the brightness from the instance, making our guy a black silhouette against the lighter background.

9. Create a motion tween, starting in this frame.

 With this tween in place, the guy will fade in from a silhouette to a fully colored figure while the background is growing steadily darker.

PROCEDURE 6: A WORD BALLOON

1. Create a new layer named **Balloon** at the top of the layer list.

2. Go to the **Window** menu and choose **Toolbar, Controller** (Windows) or **Controller** (Macintosh). A small window with VCR-style controls opens.

 The controller includes a **Rewind** button that will take you very quickly to the first frame, and a **Go to End** button that rushes you to the last frame. Both of these are very handy in editing.

3. Press the **Play** button (the single arrowhead). Your movie starts to play. When you hear the lyrics "just three words" for the first time, press the **Stop** button (the square).

4. Look at the picture of the sound wave on the music layer. You can probably see three large bumps in the wave, which are the three words being sung (badly). Select the frame immediately before the start of the first bump, on the balloon layer, and insert a keyframe into it.

5. In the upper left-hand corner, draw a wide white oval with a black hairline stroke. This oval should be big enough to hold three words in a reasonably sized font.

6. Take the **Pen** tool and click on the edge of the oval. Small squares appear around the oval, indicating the points that define the circle.

7. Click the tool along the edge of the oval, between its bottommost point and a point to its left. A new point appears where you click. Add another point to the right of the bottom point.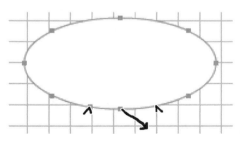

 You can tell when you are pointing at the edge: a small + appears next to the pointer.

8. Use the **Subselect** tool to drag the bottom point about one grid square down and to the right.

 While using the pen tool, hold down the Windows **Ctrl** key or the Macintosh ⌘ key. The tool becomes the subselect tool!

RESULT

PROCEDURE 7: THE GUY SINGS!

1. Using the **Text** tool , add the word **JUST** to the balloon, leaving room after or below it for two more words.

2. On the music layer, find the last frame before the *second* sound wave bump in the "just three words" phrase. Go to the **Balloon** layer and add a keyframe in that frame.

3. Add the word **THREE** to the word balloon.

4. Repeat step 2 for the *third* bump.

5. Add **WORDS!** to the word balloon.

> You can make a wider, left-justified text field in step 1 or 3, and then at the next keyframe add the next word into that text box, rather than trying to build an additional text box for it.

6. Find the first frame after the end of the third bump and make that frame a keyframe on the balloon layer.

7. Go to the **Edit** menu and choose **Cut** to erase the contents of this keyframe, so the words stay on-screen only as long as they are spoken.

8. Now the layer has three short groups of frames in the row. Click the first frame of the first segment. While holding down the **Shift** key, click the last frame of the third segment. Now all three segments are selected.

9. From the **Edit** menu, choose **Copy Frames** to copy these frames onto the clipboard.

PROCEDURE 8: REPEAT THE WORDS

1. Press **Play** again and listen until you hear the next occurrence of the lyrics then press **Stop.**

2. On the **Balloon** layer, select the frame before the first sound wave bump of the phrase.

3. From the **Edit** menu, choose **Paste Frames.** The three segments you copied appear in the layer, although the final segment stretches to go on to the very end of the movie.

Flash has a tendency to assume that anything you put on a timeline should go out to the last frame it thinks the layer should have.

4. Find the first frame after the end of the third bump and make that frame a keyframe on the balloon layer.

5. Go to the **Edit** menu and choose **Cut** to erase the contents of this keyframe, so the words stay on-screen only as long as they are spoken.

6. Repeat steps 1 through 5 for the third and fourth occurrences of the lyrics.

Why does pasting the frames keep working? After all, you keep cutting a segment in step 5, and cutting should put that material on the clipboard, right? But you keep pasting the material you copied in Procedure 7! This is because Flash actually has *two* clipboards. The *paste frames* command always pastes from the clipboard that you fill with the *cut frames* and *copy frames* commands. The commands that are just *cut* and *copy* fill a different clipboard, the one that *paste* uses.

7. Repeat steps 1 through 4 (*not* 5!) for the fifth occurrence of the lyrics, which is the last singing on the track.

PROCEDURE 9: CLEAN UP THE END

1. Hit the **Go to End** button in the Controller window. You'll find that the last frame only exists on the balloon layer; the other layers had ended earlier.

 When you first created the balloon layer, Flash thought it would end at the same place as the other layers. Whenever you used the *paste frames* command, Flash thought you wanted to insert frames so it stretched the layer by that many frames.

2. Scroll the timeline back until you see the last frames of the other layers.

3. Select the balloon layer frame that is immediately after the last frame of the other layers and insert a keyframe into it.

4. On the **Balloon** layer, double-click one of the middle frames between the keyframe you added in step 3 and the end of the layer. The entire segment becomes selected.

5. From the **Insert** menu, choose **Remove Frames.** Those frames disappear, leaving a balloon layer that ends at the same point as the other layers.

6. Add a new layer and name it **Actions.**

7. Insert a keyframe into the last frame of this layer and put the action **stop** into it. (That action is in the book **Actions, Movie Control.**)

8. Save the file under the name **Just3** and test it out.

RESULT

PROJECT 18

WEB-READY MUSIC VIDEO

CONCEPTS COVERED

❑ Measuring bandwidth usage
❑ Audio compression rates
❑ Tracking streaming status

REQUIREMENTS

❑ The music video from Project 17

RESULT

❑ A music video that plays smoothly over most Web connections, with a loading screen as it loads up

PROCEDURES

1. Set the sound compression
2. How slow does the movie load?
3. How much to preload?
4. Create a pause
5. Tell them it is loading
6. Show how fast it is loading
7. Test it out!

PROCEDURE I: SET THE SOUND COMPRESSION

1. Reopen the **Just3** movie file that you saved in Project 17.
2. Open the library and double-click on the icon next to the song file name. A dialog box opens.

 Be sure to double-click the icon, *not* the song name. If you double-click the song file name, Flash thinks you want to rename it!

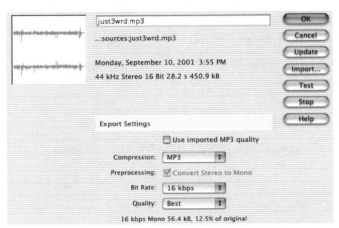

3. Clear the **Use imported MP3 quality** check box, make sure **Compression** is set to **MP3,** and set the **Bit Rate** to **16 kbps.**

 The *bit rate* is the amount of data that the system stores for each second of music. A high bit rate makes for better sound reproduction, but it makes it hard for people's modems to download the music fast enough. If someone's modem can't keep up, the music will pause or skip. The 16 *kbps* (that's *kilobits per second* or how many thousands of pieces of computer data are sent each second) is about the lowest speed you want to use for compressed music. Even at that, the music will sound quite cruddy. Luckily, this song was cruddy to begin with so you haven't lost much!

4. Set **Quality** to **Best** then click **OK.**

 The quality option *Fast* will not help slow modems keep up. That just speeds up the compression that is about to take place on your machine. It is better to wait a little while longer to get the best quality that can be squeezed into 16 kbps.

PROCEDURE 2: HOW SLOW DOES THE MOVIE LOAD?

1. From the **Control** menu, choose the **Test Movie** command. The Flash player starts playing the movie. Either wait for it to end, or go to the **Control** menu and choose **Stop.**

2. From the **Debug** menu, choose **28.8 (2.3 KB/s).**

 This is the speed of the modem you'll be simulating—what is referred to as a *28 Kb modem.* It is about the slowest speed that anyone is likely to use to view Flash animations.

3. From the **View** menu, choose **Bandwidth Profiler.** A graph and other information appear above the movie.

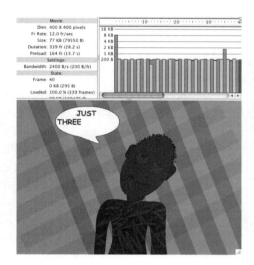

4. Look at the graph. It shows how much information has to be downloaded to the viewer before it can show each frame. For example, the first frame requires a lot of information to be downloaded, because the head-boppin' guy and the background stripes have to be downloaded before it can be viewed. Once those things are downloaded, most of the other frames are all set up, only needing the music for that twelfth of a second to be downloaded. If you look, you'll probably see another frame's bar sticking up above the rest. This is the frame where the word balloon first appears.

A DEEPER UNDERSTANDING: BITS AND BYTES

A *bit* (sometimes abbreviated with the lowercase *b*) is the smallest possible unit of computer data, able to store either a zero or a 1. A *byte* (an uppercase *B*) is a set of 8 bits combined; one byte can be used to store a single letter in a text message. The prefix *kilo* (abbreviated *K*), which is used in most measurements to mean a thousand, is used in data measurements to mean 1024 (a number that is awkward for humans but handy for computers). So a *kilobit (Kb)* is 1024 bits, and a *kilobyte (KB)* is 1024 bytes.

RESULT

PROCEDURE 3: HOW MUCH TO PRELOAD?

1. Click on one of the bars of the graph. Don't choose one of the big bars, just one of the normal-sized ones. In the data area on the left, under *State,* you'll see the number for this frame. You'll also see a measurement of how much information this frame needs, which will say something like *0KB (295 B),* which means that this frame needs 295 bytes of information before it can play. That is a problem because as you can see looking under the *Settings* header, this modem downloads at a speed of *200 B/fr;* that means that for the time of playing each frame (one-twelfth of a second) it can get 200 bytes under typical Internet conditions.

Movie:	
Dim:	400 X 400 pixels
Fr Rate:	12.0 fr/sec
Size:	77 KB (79550 B)
Duration:	339 fr (28.2 s)
Preload:	164 fr (13.7 s)
Settings:	
Bandwidth:	2400 B/s (200 B/fr)
State:	
Frame:	40
	0 KB (295 B)
Loaded:	100.0 % (339 frames)

2. Try clicking on a few other typical bars. You'll see that they average something close to but less than 300 bytes per frame. Use 300 as an estimate of how many bytes it takes to download the typical frame (this is one of those estimates in which it is better to estimate a little high than a little low).

3. Divide 200 (the number of bytes that are downloaded in a twelfth of a second) by 300 (the number of bytes that play during each twelfth of a second), and you get two-thirds (or .66666666, for those of you using calculators). That means that in the time it takes to play the entire video, you could download two-thirds of the frames, if they were all made up of typical frames.

4. Drag the scroll bar under the graph to scroll through the last two-thirds of the movie. You'll find that it is all made up of typical frames; the two bigger-than-typical frames are in the first third. If you could just download the first third of the movie before the movie started playing, then you could play the entire movie without it pausing waiting for data, even on a fairly slow modem.

5. In the data to the left side of the graph, find **Duration.** The value there is the number of frames of the entire movie. Divide that number by 3 to find out how many frames are in the first third of the movie. Round that number up to the next highest frame and write it down.

6. Close the player window to return to the editing window.

PROCEDURE 4: CREATE A PAUSE

1. Find the frame you calculated as the one-third point in the movie and select it by clicking on it on the **Actions** layer. Insert a keyframe into that frame.

2. On the properties display type **OneThird** into the **<Frame Label>** field.

3. As you did in Project 5, Procedure 1, create a new scene and put it before the existing scene.

4. Take **Layer 1** and rename it **Actions.** Select frame **1.**

5. Open the **Actions** panel, and in the **Deprecated, Actions** book double-click on the **ifFrameLoaded** entry. The command appears in the script area.

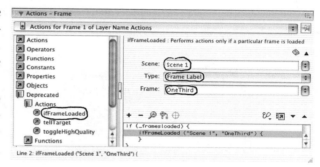

6. In the parameters area, set the **Scene** drop menu to **Scene 1,** the **Type** drop menu to **Frame Label,** and the **Frame** drop menu to **OneThird.**

 Set those in that order. If you try to set the *Frame* menu before setting the *Type* menu, you won't even find *OneThird* on the list.

7. In the **Actions, Movie Control** book, double-click on **goto,** then set the **Scene** drop menu to **Scene 1.**

8. Insert a keyframe into frame **2** of this layer.

9. On the **Actions** panel, double-click the **goto** command again. Because the default parameters are for this to go to and play frame 1, you don't need to set the parameters. Now you have a pair of commands that loops between two frames, waiting for the specified frame to load.

A DEEPER UNDERSTANDING: DEPRECATED COMMANDS

Every time Macromedia releases a new version of Flash, they add some new programming features and *deprecate* others, telling designers that they shouldn't use those features. It doesn't mean that the features don't work—if they stopped old features from working, then the new viewer couldn't show old Flash movies. Instead, this deprecation just means that they think there is a better way to program the same thing.

RESULT

PROCEDURE 5: TELL THEM IT IS LOADING

1. Create a new layer named **Text** and select frame **1** of that layer.
2. Get the **Text** tool . Set the **Text type** to **Static Text,** the **Font** to **Impact,** the **Font Size** to **180,** and the **Text (fill) color** to black.

 You'll have to type in the font height; the slider doesn't go that high.

3. Drag a text box all the way across the stage and type **WAIT** into it.

You want this scene to take up as few bytes as possible, so that the time will be spent downloading the main movie and not the wait-for-the-movie scene. *WAIT* has few letters, and in the Impact font they are all made up of straight lines so they compress very well.

4. Click the **Arrow** tool button to select the text box, then convert the text box into a movie clip symbol.
5. On the properties display type **Sign** into the **<Instance Name>** field.

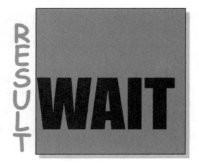

PROCEDURE 6: SHOW HOW FAST IT IS LOADING

1. Select frame **2** on the **Actions** layer's timeline and open the actions panel.

2. Put the actions panel into expert mode.

3. Add the command **downloaded=_framesloaded/113;** after the command that is already there but instead of 113 put the frame number you calculated as the one-third point plus 2.

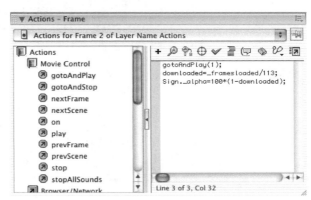

 This line calculates what fraction of the frames you're waiting for have already been downloaded. The _framesloaded_ property stores how many frames have already been downloaded. You add 2 to the number you calculated earlier, because you also have to download the two panels of this scene.

4. Add the command **Sign._alpha=100*(1-downloaded);** to this action.

 The phrase *(1-downloaded)* calculates the fraction left to download. The * symbol is the computer term for *multiply;* you're multiplying a fraction by 100 to express it as a percentage. Then you're setting *Sign._alpha,* which is the alpha value of the text, to this percentage. The more that gets downloaded, the lower the alpha is, so the word fades away.

A DEEPER UNDERSTANDING: GOTO COMMANDS

You may notice that the gotoAndPlay command in this action is now before some other commands. You may be wondering "if it hits that first command, then goes back to frame 1, how does it ever get to the other two commands in the action?" Good question! Actually, the gotoAndPlay command (and similar commands) don't work immediately. Instead, they just set the number for the next frame. Flash doesn't move to that next frame until it has finished the actions in this one.

PROCEDURE 7: TEST IT OUT!

1. From the **Control** menu, choose **Test Movie.** The player window opens and the movie plays.

2. If the graph isn't showing, go to the **View** menu and choose **Bandwidth Profiler.**

3. Go to the View menu and choose **Show Streaming.** The movie starts playing as though it were being downloaded by a modem. Watch the timeline at the top of the graph. A little pointer will show the frame that is currently playing, while a colored bar shows which frames are currently loaded. The pointer should move to frame 2 and then wait there while the colored bar continues on. The word *WAIT* fades as the download bar continues moving. When the bar reaches the designated frame, the music and motion start.

4. Did something go wrong? If the word *WAIT* doesn't fade, but everything else works, you may have picked the wrong font (changing alpha levels doesn't work for the device fonts at the bottom of the font list), chosen the wrong text type (you can't change the alpha for input text), or misnamed the instance. If there is any other problem, you probably made an error entering an action; go back to the movie and check those carefully.

5. Close the player window then save the file.

 Save it as **Just3slo,** so you don't overwrite the version you made in Project 17. That version sounds better because the music is less compressed. This version is better for the Web.

6. Publish the file, then enjoy the movie in your browser!

 Don't expect to see the WAIT message when you play this through the browser on your computer. Your browser will load the entire movie from disk instantly so it won't sit there with the message showing.

PROJECT 19
AN ANIMATED BUSINESS CARD

CONCEPTS COVERED

- ❏ Sleek styling
- ❏ Dividing one layer into several
- ❏ Stopping a sound

REQUIREMENTS

- ❏ A digital photo (you can use the same one you used for Project 6)

RESULT

- ❏ Pieces fly across the screen to form a business card.

PROCEDURES

1. Start at the end
2. Add text
3. Put a line on a new layer
4. Animate the line
5. Animate the other lines
6. Rolling in the block
7. Reveal the text
8. Finish up the visuals
9. Line-sliding noise

PROCEDURE 1: START AT THE END

1. Create a new file with a **Width** of **550** pixels and a **Height** of **400** pixels, a **Frame Rate** of **20** fps, and the **Background Color** set to a light shade.

2. Import your photo as you did in Project 6, Procedure 1.

3. Use the **Free Transform** tool ⊞ with the **Scale** option ▣ to resize and reposition the photo. You want it to take up about one-quarter of the width of your stage, with the left edge being at the center of the stage.

> **TIP** If you resize by dragging one of the corner sizing handles, the photo enlarges in both dimensions rather than squashing or stretching.

4. From the **Modify** menu, choose **Break Apart** so that Flash thinks of the photo as an editable item.

5. Using the **Rectangle** tool, drag a rectangle with no fill and a solid 4 point black stroke around the edges of the picture.

> **TIP** Open the **View** menu and make sure **Snap to Objects** is selected. This makes it easy to match the rectangle precisely to the sides of the photo.

6. Go to the **Edit** menu and choose **Select All** to select the photo and its stroke.

7. Create a second copy of the outlined photo by using the **Arrow** tool ▸ to drag it while holding down the **Shift** key (to keep the movement strictly horizontal) and the Windows **Alt** or Macintosh **option** key. Place it so that the right edge of the copy is right on the left edge of the original.

8. Click the **Fill Color** button and select a light color. The entire copy of the picture becomes that color, leaving you with a colored rectangle that is exactly the same size as the photo. This is the basic design of what your card will look like at the end of the animation.

RESULT

PROCEDURE 2: ADD TEXT

1. Using the **Text** tool, add appropriate business card text over the colored rectangle but leave out your name. Make the text black and use your own choice of fonts and sizes.

2. On a blank area of the stage, create another text box with your name in it. Use a color that will show up well over your photo, make it narrower than the photograph, and don't use a device font.

 You're working away from the photo simply to make what you're working on easier to select.

3. Click the **Arrow** tool button ☐ to select the text.

4. Create a second copy of the text right over the first by going to the **Edit** menu, choosing **Copy,** then returning to the **Edit** menu and choosing **Paste in Place.**

5. Click the cursor down key 3 times then click the cursor right key 3 times to move the copy so that it is not precisely on top of the original.

6. Go to the **Modify** menu and choose **Break Apart**, then choose the same command again.

 You'll vary the alpha value of this copy. Flash has some problems with lowered alpha values on text objects, so you've turned it into a shape object.

7. On the **Color Mixer** panel set the **Fill Color** to black and **Alpha** to **50%.** (Because the letters are still selected, the decrease in alpha won't be visible yet.)

8. Use the **Arrow** tool to drag a rectangle around both the original text and the copy to select them. From the **Modify** menu, choose **Group** to turn the selection into a single unit, which you should then position over the picture.

PROCEDURE 3: PUT A LINE ON A NEW LAYER

1. Using the **Arrow** tool [arrow icon] , click on the top line of the photo's black border to select it. Notice that only the line above the photo gets selected, not the rest of the rectangle nor the line above the colored area (which really looks like the same line at this point).

2. While holding down the **Shift** key, click on the top line of the rectangle around the colored area. Now the whole line across the top of the business card is selected.

3. From the **Edit** menu, choose **Cut.** The line is removed from the picture and stored on the clipboard.

4. Create a new layer named **Top line.**

5. Select frame **10** of that layer and insert a keyframe there.

6. From the **Edit** menu, choose **Paste in Place.** The line appears in the same spot that it was in on the business card. However, because Layer 1 doesn't extend to frame 10, you won't see the rest of the business card.

RESULT

PROCEDURE 4: ANIMATE THE LINE

1. Insert a keyframe into frame **30** of the **Top line** layer.
2. Select frame **10** of this layer.
3. By holding down the **Shift** key and pressing the right cursor key, move the line until it is off the right side of the frame. (You may need to zoom out or scroll your editing window in order to see the right side of the frame.)

 You're using the cursor key instead of dragging with the mouse because you don't want to accidentally move the line up or down at all. When using the cursor keys, the shift key makes the object move faster.

4. Using the **Free Transform** tool ⊞ with the **Scale** option ⊡ , drag the right sizing handle on the line to the left until it touches the left sizing handle.
5. Click the current frame on the timeline to show the frame information on the properties display.
6. Set the **Tween** drop menu to **Shape** and set **Ease** to **−100**. Now if you test the movie, you'll see the line spurting out from the right side and expanding into place.

RESULT

PROCEDURE 5: ANIMATE THE OTHER LINES

1. Using the techniques from Procedures 3 and 4, take the vertical line from the far left of the business card and put it on its own layer, having it appear zooming down from the top starting with frame **20** and be completely in place in frame **40**.

2. Make the line on the right of the business card zoom down from the top starting with frame **30** and ending with frame **50**.
3. Make the line across the bottom zoom in from the left starting with frame **40** and ending with frame **60**.
4. Make the line that separates the colored area from the photo zoom in from the bottom starting in frame **50** and ending in frame **70**.

RESULT

PROCEDURE 6: ROLLING IN THE BLOCK

1. Using the technique from Procedure 3, put the colored rectangle on its own layer starting in frame **20**. Name the layer **Block.**
2. Insert a keyframe into frame **40** of this layer.
3. Insert another keyframe into frame **30** of this layer.
4. With frame 30 still selected, use the **Free Transform** tool with the **Scale** option to drag the bottom edge of the rectangle down so it touches the bottom of the frame.
5. Select this frame on the timeline then set **Tween** to **Shape.**
6. Select frame **20** of this layer.
7. Again using the **Scale** option, first drag the bottom edge of the rectangle to the bottom of the frame, then drag the *top* edge of the rectangle down to the bottom edge of the frame. The rectangle should now be just a line down at the bottom of the frame.
8. Again, set **Tween** to **Shape.**
9. On the layer list, move this layer so that it is below all of the line layers.

When Flash puts a stroke around an object, the stroke actually overlaps the edge of the object. If you put this rectangle on a layer above the line, the rectangle would overlap the line rather than the other way around. This would make the line a little thinner and the rectangle a little larger.

PROCEDURE 7: REVEAL THE TEXT

1. Take the text from the left part of the business card and put it in its own layer, named **Card text,** starting in frame **70.**

 Put this layer above the rectangle's layer on the layer stack; otherwise, the rectangle will cover up the text.

2. Insert a frame **100** into this layer.

3. Create a new layer named **Text mask,** immediately above the Card text layer.

4. Insert a keyframe into frame **70** in this new layer and draw a circle (any color) that completely covers the card text.

5. Insert a keyframe into frame **100** of this layer.

6. Select frame **70** of this layer and resize the circle so that it is as small as possible in the middle of the text.

7. On the frame panel, set **Tweening** to **Shape.**

8. Make this layer a mask layer, as you did in Project 10, Procedure 4.

 The effect this will have is what animators call an *iris out,* revealing just the start of the text at first and then expanding the amount that is revealed.

RESULT

Princess-for-t.
trained in the arts of
aeronautics, acrobatic
tea-service, kung-fu,
bubble-blowing,
acorn-eating, arr
nais.

PROCEDURE 8: FINISH UP THE VISUALS

1. Move the name from over the photo onto its own layer named **Name**, starting with a keyframe in frame **100** and ending with a keyframe in frame **130**.

 After this step, the only thing that should be left on your original layer is the photo. If you still have some other element there, look back through the procedures and see what you might have missed.

2. In frame 100 of this layer, move the name out of the frame. If the name is near the top of the photo, move it straight down to be off the bottom of the frame. If the name is near the bottom of the photo, move it straight up to be off the top of the photo.

3. Go to the **Insert** menu and choose **Create Motion Tween** so that the name slides into place.

4. Insert a frame **130** into the rest of the layers of the image so that once everything appears on the scene, it doesn't disappear.

5. Select the final frame of the **Name** layer. Open up the **Actions** panel and insert a **Stop** action into this frame so the movie ends rather than repeating.

6. Test the movie then return to the editing window and change the movie's **Frame Rate** and test it again. Because the animation is so simple, you can increase the frame rate without having pauses and slowdowns. Find a rate you like, whether fast or slow.

 To bring up the movie properties on the properties display, just click a blank area of the stage.

PROCEDURE 9: LINE-SLIDING NOISE

1. Create a new layer named **Noise** and insert a keyframe into frame **10** (the frame where the lines start moving).

2. Using the technique from Project 2, Procedure 3, locate an appropriate sound in the common libraries and drag it onto the stage.

3. Insert a keyframe into frame **70** of this layer. The lines have stopped moving at this frame.

4. On the properties display open the **Sound** drop list, and select the name of the sound you just added. Set **Sync** to **Stop**.

 This command stops the sound from playing, even if the sound is not done or if it is repeating.

5. Select frame **10**.

 Don't try to rearrange the steps here. Because you're going back to frame 10, it is tempting to set the following settings when you're there for the first time. However, due to an oddity in Flash, choosing the stop setting in frame 70 can reset the settings from frame 10. Because of this, you're better off setting the settings in frame 70 before the ones in frame 10.

6. Set **Sync** to **Start** and **Loop** to **999**.

 You want to make sure the sound repeats until you tell it to stop. This way, you don't have to recalculate the length of the sound or the number of repetitions if you change the frame rate, as you did in Project 4.

7. Save your file. You now have a reverse-exploding business card, which will help your business explode!

Project **20**

Closing Credits

CONCEPTS COVERED

- ❑ Character animation
- ❑ Translucent gradients
- ❑ Exporting a QuickTime movie

REQUIREMENTS

- ❑ You'll need a copy of the QuickTime player (available from www.quicktime.com, although many computers already have it installed) to see the results. If you don't want to get QuickTime, don't worry; you can just save a second copy of the results in a different format.

RESULT

- ❑ An animation of a stickman walking up a sidewalk, while text scrolls in front of him

PROCEDURES

1. Draw nature
2. Lay some concrete
3. Make the sidewalk scroll by
4. The stickman cometh
5. Fashion a stride
6. Create credits
7. Scroll the text
8. Make a QuickTime file

Procedure 1: Draw nature

1. Create a new file with a **Width** of **300** pixels, a **Height** of **300** pixels, and a **Frame Rate** of **10** fps.

2. Using the method from Project 7, Procedure 1, create a linear gradient that starts blue, fades to white in the middle, then right next to the white is dark green, which fades to light green at the end.

3. As you did in Project 7, Procedure 2, make a rectangle that spreads this gradient from the top of your image to the bottom, covering the entire frame.

4. Create a new layer named **Sun** above the first layer.

5. As you did in Project 7, Procedure 3, create a radial gradient, but make both ends of the gradient the same color yellow.

6. Click on the pointer at the right end of the gradient design to select it.

7. Set **Alpha** to **0%.**

 When you do this, you'll have a gradient that is one color but solid in the center, fading to completely transparent at the edge. This is a simple but sufficient emulation of the sun and its glow.

8. Draw a circle with this fill in the sky.

PROCEDURE 2: LAY SOME CONCRETE

1. Create a new layer named **Sidewalk** at the top of the layer list.

2. Get the **Rectangle** tool . Choose a medium gray **Fill Color** and set the **Stroke Color** to **No Color** .

3. Draw a rectangle with the upper-left corner on the horizon about two-fifths of the frame width from the left side, and with the lower-right corner on the bottom edge of the frame two-fifths of the way from the right side.

4. Use the **Subselect** tool (shortcut: **a**) to drag the lower corners of the rectangle outward so that the base of the rectangle (which is now a trapezoid, actually) takes up about half the width of the image.

5. Select the trapezoid and convert it to a graphic symbol named **Cement.**

6. Open the **Cement** symbol for editing.

7. Insert a new layer named **Section lines.**

8. Use the **Line** tool (shortcut: **n**) to draw a black hairline across the bottom of the trapezoid.

9. Draw another line across the trapezoid about one-third of the way to the top, another line about one-third of the way between that line and the top, and another line that cuts the remaining portion in half. These are the lines that separate the individual blocks of the sidewalk.

RESULT

PROCEDURE 3: MAKE THE SIDEWALK SCROLL BY

1. Insert a frame into frame **13** of the layer with the cement.
2. Insert a keyframe into frame **13** of the **Section lines** layer.
3. From the **Edit** menu, choose **Deselect All.**
4. Click the **Arrow** tool on the line at the bottom of the trapezoid, then press the **Delete** key to delete it.
5. Use the **Line** tool to draw a black hairline across the top of the trapezoid.
6. Select frame **1** of **Section lines** layer.
7. On the properties display set **Tween** to **Shape.**
8. From the **Control** menu, choose **Loop Playback** then choose **Play.** You should see the four lines moving up the trapezoid, with a new line appearing at the bottom whenever a line hits the top. This simple animation looks the way an uphill sidewalk would look if you were walking backwards on it, each block of the sidewalk shrinking off into the distance as you walk away from it. This works because the top line in frame 1 is being tweened to the top line in frame 12, the bottom line is tweened to the bottom line, and the two in-between lines are tweened to the in-between lines.
9. Select frame **1** on the **Section lines** layer.
10. From the **Insert** menu, choose **Remove Frames.**

 Before you do this, the animation appears to pause when it loops because three lines are in the same places in frames 13 and 1. Eliminating what was frame 1 makes the animation smooth.

11. Select frame **1** of the layer with the cement. Remove that frame as well, so that both layers now last 12 frames.

RESULT

PROCEDURE 4: THE STICKMAN COMETH

1. Return to editing the scene.
2. Create a new layer named **Stick figure** at the top of the layer stack.
3. Use the **Brush** tool to paint a stick figure. Have the leg on the left bent back and the right one stuck out straight, with the straight leg's foot lower in the image than the bent one's. This is a person walking, the straight leg stepping forward.

> **TIP** Don't worry about trying to make your stick figure too realistic. It's a stick figure! If the motion ends up looking exaggerated or odd, that's fine. Cartoons always walk oddly. Certainly don't try to make the lines perfectly straight; the little variations will make the character's walk seem lively.

4. Click on the layer name **Stick figure** on the layers palette to select only this layer.
5. Go to the **Insert** menu and choose **Convert to Symbol** to turn this figure into a graphic symbol named **Guy**.
6. Open the symbol for editing.

PROCEDURE 5: FASHION A STRIDE

1. Insert a keyframe into frame **10** of **Layer 1** of the symbol.

2. From the **Modify** menu, choose **Transform, Flip Horizontal.** The figure is replaced with its mirror image so that the leg that was bent in is now extended and vice versa.

3. Select frame **1** then set **Tween** to **Shape.**

4. Go to the **Modify** menu and choose **Shape, Add Shape Hint.** A red circle with the letter *a* on it appears right in the center of the image, which means it is overlapped by the crosshairs. Drag that circle to the end of the foot on the left.

5. Select frame **10.** There you'll find a matching red circle in the center of the image. Drag it to the end of the foot on the left of this frame to tell Flash that you want the left foot from the previous frame to tween into the position of the left foot on this frame.

TIP When you put this second shape hint dot into place, it should turn green to show that Flash recognizes both hints as being on an edge of an object. If it doesn't, try moving it and double-clicking it. If that doesn't help, go back to frame 1 and try the same thing. The dot in frame 1 will turn yellow when both are properly aligned.

6. Repeat steps 4 and 5, putting shape hints at the end of the other foot, both arms, both knees, and the bikini area (if, indeed, stick figures wore bikinis).

7. Insert a keyframe into frame **20,** flip the figure, and use this same technique to build a tween between frames 10 and 20 so that the figure steps forward with the other leg.

..

A DEEPER UNDERSTANDING: HINT PLACEMENT

With a complex shape, particularly one with a hole in it like this stick figure, Flash will sometimes tween the shape in unexpected ways, seeming to turn the figure inside out. If you click on an in-between frame and see an unrecognizable blob, add a few more hints. If that fails, go to the **Modify** menu, choose **Shape, Remove All Hints,** and try again. Placing hints in the counterclockwise order sometimes helps.

RESULT

PROCEDURE 6: CREATE CREDITS

1. From the **Insert** menu, choose **New Symbol.** In the dialog box that opens, set **Behavior** to **Graphic** and **Name** to **Credits** then click **OK.**

2. Go to the **View** menu and choose **Rulers** to turn the rulers on.

3. Get the **Text** tool [A] and click the **Center justify** button.

4. Set the **Text (fill) color** to a color that is not in the rest of the movie, such as red or purple. Set **Text type** to **Static Text.**

5. Click toward the top of the stage, horizontally centered (the positioning line on the top ruler should be at **0**). A small text box appears. This text box will be fine, however; when you click a text box instead of dragging it into place, the text box will automatically expand to fit the text you type into it.

6. It is time to type a list of credits for your animation. Type **Directed by** and then your name and then press **Enter** or **Return.** Then do the same thing for **Produced by, Written by, Animated by,** and all the other credits you can come up with. Be sure to give a starring credit for your stick person!

7. Go to the **Edit** menu and choose **Select All.** The text becomes highlighted.

 Normally when you do this command, it selects everything in the current frame. However, when you're editing text, this just selects the text in the current text box.

8. Click the drop arrow next to the **Font Size** field, and use the slider to alter the size of the characters. As you do this, the size of the text box adjusts to fit the widest line of text. Find the size that comes as close as possible to making the box 300 pixels wide. On the ruler, that should stretch from the 150 mark on the left side of 0 to the 150 mark on the right.

PROCEDURE 7: SCROLL THE TEXT

1. Click on **Scene 1** above the left of the stage to return to editing the main scene.

2. Create a new layer named **Text** on the top of the layer list.

3. Open the library and drag **Credits** onto the new layer.

4. Use the **Arrow** tool to drag the credits down so that the very top of the text box is just below the bottom of the frame, horizontally centered

5. Insert a keyframe into frame **300** of this layer.

6. Holding down the **Shift** key while pressing the cursor up key, move the text straight up until the bottom of the text is just above the top of the frame.

7. Select frame **299** of the current layer then set **Tween** to **Motion**. Flash creates a tween between frame 1 and frame 300 of this layer.

8. Insert a frame into frame **300** of all the other layers so they stay on screen until the end.

9. Save and test your movie.

Don't ask yourself "What is a sidewalk doing in between two large green fields? Aren't sidewalks normally alongside of *something*, like a street or at least a building?" Like most modern movies, this one falls apart if you try to think about it logically.

PROCEDURE 8: MAKE A QUICKTIME FILE

1. From the **File** menu, choose **Export Movie.**
2. On the file browser that appears, enter a name for the file and set the **Format** droplist to **QuickTime Video.**

 Don't change the **.mov** filename extension that Flash gives the file. That is needed for some systems to recognize this as a QuickTime file.

3. Click **Save.** A dialog box appears.
4. If you're using a Macintosh, set the **Width** and the **Height** to **300** pixels, the **Format** to **24 bit color,** and select the **Smooth** option. Set **Compressor** to **Video** and drag the **Quality** slider all the way to the right.

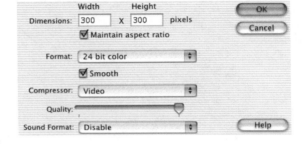

 Without the option to smooth the image, the shapes in your image might have visible blocky stair shapes at the edges.

5. If you're using Windows, select the **Match Movie** and **Flatten (Make self-contained)** options.
6. Click **OK.** The file is saved. If you have QuickTime installed on your system, you can view the file with the QuickTime viewer or with your Web browser. If you have video-editing software, you may be able to use these credits with your home movies!

A DEEPER UNDERSTANDING: QUICKTIME

There is much more to using QuickTime and Flash together than there is room to cover here. The QuickTime player can play interactive Flash movies, and you can even embed QuickTime movies inside Flash movies. There are also more QuickTime options, which you can find if you go to the **File** menu, choose **Publish Settings,** click the **QuickTime (.mov)** option, and click on the **QuickTime** tab that appears.

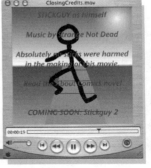

RESULT

INDEX